The Campus History Series

MUSKINGUM COLLEGE

On the cover: Please see page 62. (Courtesy of the Muskingum College archives.)

The Campus History Series

MUSKINGUM COLLEGE

Heather Giffen, William Kerrigan, and Ryan Worbs

ARCADIA
PUBLISHING

Copyright © 2009 by Heather Giffen, William Kerrigan, and Ryan Worbs
ISBN 978-0-7385-6110-3

Published by Arcadia Publishing
Charleston SC, Chicago IL, Portsmouth NH, San Francisco CA

Printed in the United States of America

Library of Congress Catalog Card Number: 2008934540

For all general information contact Arcadia Publishing at:
Telephone 843-853-2070
Fax 843-853-0044
E-mail sales@arcadiapublishing.com
For customer service and orders:
Toll-Free 1-888-313-2665

Visit us on the Internet at www.arcadiapublishing.com

*Dedicated to Dr. William Fisk and Dr. Lorle Porter,
whose tireless efforts to preserve the history
of Muskingum made this book possible.*

home again!
Hertha is doing better! Last Sunday she was in Freising. And she already made some christmas cookies!
I'm sending you a book about the history of Muskingum College. I don't know if it is interesting because I have not read it! But I hope you enjoy reading it!
I hope everything is fine with Martin and you, and I wish you a wonderful christmas and then a good start into the new year!

Kathi

New Concord, 12-11-09

Hello Mary, hello Martin!

Thank you so much for the things you've sent me! I got them yesterday. Yesterday I had my last exam. And I think it wasn't very hard! After my exam I got my key for my new room. I am moving into a single room with my own bathroom! I get this room because next semester I'm going to be a teaching assistant for german! The TA for this semester had to leave, so the german professor asked me if I want the job! I am really excited about that! Today I already cleaned the room, and later I have to move my things.
Tomorrow I am already going home for Winter Break! I'm really looking forward to be back

CONTENTS

Acknowledgments		6
Introduction		7
1.	Humble Beginnings: 1837–1903	9
2.	Building for the Ages: 1904–1931	29
3.	Realizing a Dream: 1932–1962	65
4.	A College in Transition: 1962–1978	95
5.	Pathways to the Present: 1978–2009	113

Acknowledgments

The authors of this pictorial history of Muskingum College wish to express their sincere gratitude to these individuals and institutions whose help made this book possible: the Alpha Sigma Alpha sorority Zeta Omicron chapter, Jennifer Bronner, Margie Brown, Russ Brown, Center for Regional Planning (for providing work space), Beth Dalonzo, Susan Danneman, Sheila Ellenberger, Janet Heeter-Bass, Rod Lang, Jennifer Lyle, Janice Tucker McCloud, Mark Miller, the Ohio State University Archives, Nicole Robinson, Penny Selock, George St. Clair, Larry Shank, Taylor and Jan Stults, Andrea Sommers, the Theta Phi Alpha sorority Beta Delta chapter, Sarah Weaver, Andrew Whitis, and Jeff Zellers.

Special thanks are due to Muskingum College president Anne Steele, vice president for academic affairs Paul Reichardt, and the Muskingum College Board of Trustees for their continued support of the Muskie Summer Fellows program, which made this book possible, and to the Center for Regional Planning for providing workspace. All royalties from the sales of this book will go to the George and Jean Schooley Fund to support scholarship awards for Muskingum College history majors. The images in this book, unless otherwise noted, come from the Muskingum College archives.

<div style="text-align: right;">
Heather Giffen, William Kerrigan, and Ryan Worbs

Department of History, Muskingum College

New Concord, August 2008
</div>

INTRODUCTION

A journey through the foothills of southeastern Ohio on U.S. Interstate 70, or perhaps the historic National Road, will take you through the village of New Concord. Atop the hills that rise from Main Street sits Muskingum College, its buildings discernable through the trees even from the interstate because of the trademark red tile roofs that adorn much of campus. This pictorial history is an account of the remarkable history of that pioneering college.

In many ways, the story of Muskingum College is the story of American higher education in microcosm. Muskingum was one of the hundreds of institutions of higher education established in the trans-Appalachian west during the first half of the 19th century. Like most small private institutions in these years, Muskingum College depended upon the commitment of local champions of higher education to keeps its doors open; a small devoted faculty worked tirelessly to foster a love of learning and commitment to Christian idealism in their young charges. With the dawning of a new century, Muskingum experienced dramatic growth in its student body, and the expansion and modernization of both its facilities and curriculum. Of course Muskingum College increasingly felt the influence of a wider world as a series of technological innovations drew New Concord out of its rural isolation: the automobile, improved roads, and ultimately interstates seemed to reduce physical distance; in succession the technologies of radio, television, the internet, and the cell phone brought the world onto campus, and ultimately altered notions of community, identity, and place. And across this century of rapid technological change, those tasked with keeping the institution fiscally healthy and up-to-date faced the disruptions of war and cycles of economic prosperity and stagnation that provided a new set of challenges for virtually every decade.

Yet while Muskingum faced most of the same challenges and opportunities that other colleges did in these years, it blazed its own path in response to them. Sometimes the college's responses to a changing world seem quaint and provincial in retrospect, such as the effort to maintain the prohibitions on dancing and card playing during the Roaring Twenties. But more often, the stories that demonstrate Muskingum's reluctance to follow the crowd celebrate its admirable commitment to independence and determination to stay true to its core values. When Muskingum College sent missionaries to all parts of the globe and built strong relationships with Ethiopia in the 1920s and 1930s, it demonstrated a commitment to a compassionate internationalism in an age of fearful isolationism. Again when Muskingum invited eight Nisei students to the campus to keep them out of

wartime relocation camps, it proved its commitment to doing what was right rather than what was popular. That independence continues to manifest itself more recently in bold strategies like tuition repricing in an age of tuition inflation, and the development of new programs to meet the changing needs of the region. Perhaps that spirit is best captured in the cornerstone of the new Walter K. Chess Center, which reads "Test everything, hold fast to that which is good," (1 Thessalonians 5:21).

The authors of this book attempted to capture the true spirit and essence of the college while at the same time providing an informative and engaging narrative of Muskingum's history. We tried to select photographs and write captions that told the college's unique story rather than forcing the history of the Muskingum to conform to the mold of the mainstream American experience. Our goal was to allow each photograph and document to convey directly to the reader its place in what has come to be known as the Long Magenta Line, the traditions of the college and its alumni. As you turn through the pages of this book, we invite you to return home to that college on the hill, or perhaps visit it for the first time.

One

HUMBLE BEGINNINGS
1837–1903

When residents of New Concord gathered on January 25, 1837, to form the "Friends of Education" and launch plans for a university, the odds against success were great. Four out of five American colleges and universities founded before the Civil War would close their doors forever before that conflict had begun. In their petition for incorporation to the state legislature, the friends declared that "New Concord is a most eligible site for a literary institution. It is a town noted for order and industry, it is easy of access, being situated on the national road, it is in the heart of a fertile country densely inhabited by people friendly to literary pursuits." They made a convincing case, and on March 18, 1837—since commemorated as Founder's Day—the legislature passed a bill to incorporate Muskingum College.

While the Friends of Education proposed a college that would be non-sectarian, from the outset Muskingum College was directed by men of Scots-Irish heritage belonging to various branches of Presbyterianism. The two key early leaders were Benjamin Waddle, a minister of the Associate Reformed Presbyterian Church, and Samuel Willson, pastor at the Old School Presbyterian Church on Pleasant Hill. But the college could not have survived without the support of many town leaders, including town founder Judge David Findley and physicians John Hull and James Bell.

For most of the 19th century, the college survived on meager resources and depended upon the revenues of the Muskingum Academy—a college preparatory program—as well as the generosity of local benefactors. The small group of poorly paid faculty struggled to provide a classical Christian education. Looking backwards through a 21st century lens, the Muskingum College of the 19th century might appear rigid, provincial, and exceedingly limited in its curriculum. But a spirit of intellectual inquiry thrived on the campus during these years. Student literary societies held regular debates on important issues of the day. And the dedicated faculty devoted an extraordinary amount of attention to the small student body. That a college with meager resources and inadequate facilities whose largest graduating class in the 19th century numbered just 22 would produce two giants in the fields of higher education (William Rainey Harper and William Oxley Thompson) as well as leaders in the field of archaeology (Robert Francis Harper and Melvin Grove Kyle) is a testament to their success.

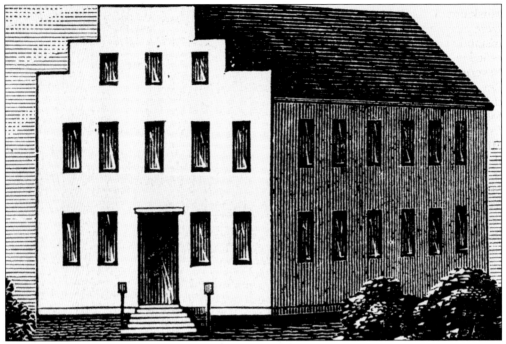

In 1837, the board of trustees began raising funds for the college's first building. William Findley donated the building site, and village residents and nearby Presbyterian congregations raised a total of $1,104 by the end of the year. The board borrowed the remaining funds, and in 1839, the college moved into this primitive and never fully finished building. In 1851, the young college would face its first major crisis when the building was destroyed by fire. (Courtesy of *Historical Collection of Ohio*, 1848.)

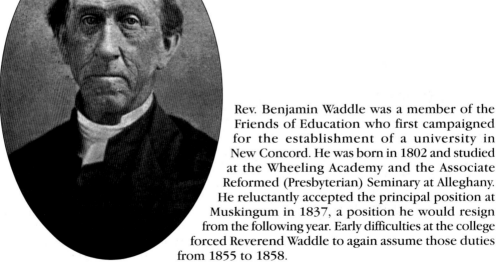

Rev. Benjamin Waddle was a member of the Friends of Education who first campaigned for the establishment of a university in New Concord. He was born in 1802 and studied at the Wheeling Academy and the Associate Reformed (Presbyterian) Seminary at Alleghany. He reluctantly accepted the principal position at Muskingum in 1837, a position he would resign from the following year. Early difficulties at the college forced Reverend Waddle to again assume those duties from 1855 to 1858.

Muskingum's earliest years were characterized by relative instability, especially in the office of the president. After Reverend Waddle stepped down, Rev. Samuel Willson assumed the position from 1838 to 1845, followed by Rev. David Wallace from 1846 to 1848, Rev. John Milligan from 1848 to 1849, Rev. Samuel G. Irvine from 1849 to 1851, and then Rev. Samuel McArthur (pictured at right) from 1851 to 1855. The rivalry between McArthur and Waddle helped to fuel a student walkout in 1856.

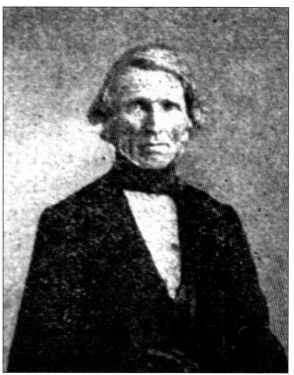

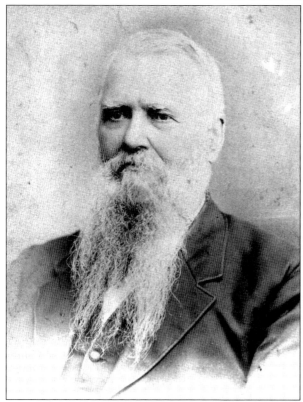

Rev. John Comin was just a boy in 1838, when he was granted the distinction of being the first to cross the threshold of the first college building. He went on to graduate in the class of 1847. Reverend Comin's family owned property just west of the college and Comin Street bears the family name. His family would continue to have contact with the school for 100 years: his granddaughter was the first president of the F.A.D. women's social club and married J. Knox Montgomery Jr., longtime vice president of the college.

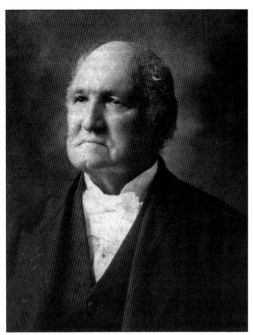

Guiding Muskingum through the years of the Civil War was president L. B. Shryock. At least 25 Muskingum students and alumni went off to fight in defense of the Union. Fears that Confederate general John Morgan and his army would raid the village struck New Concord in late July 1863. In 1865, President Shryock retired from his post and Rev. David Paul, pictured here, became the next president of the college—a post he would hold until 1879.

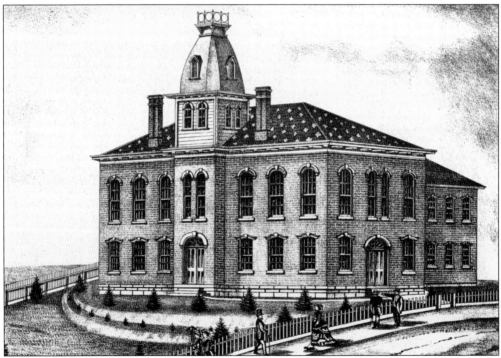

In the years before and following the Civil War, Muskingum College was plagued with difficulties posed by the refurbished structure that was erected after the 1851 fire. In 1873, college president David Paul enlisted members of the community to help raise funds for an additional building to be built in front of the existing building. The effort was a great success and raised more funds than were needed. Major contributors included merchants Alexander Speer and Samuel Harper.

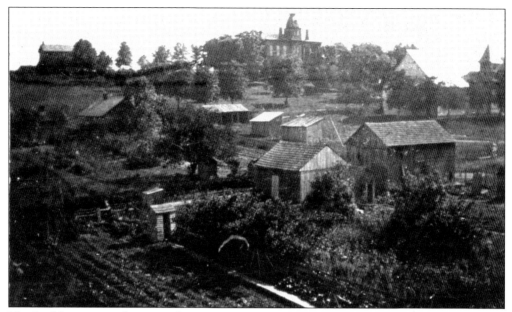

The building erected in 1873 for years was referred to simply as the college and later the "Old Building." It was not until many years later that it would be named for the president that worked so hard to see the building come to fruition. In this image, dated sometime before 1899, the United Presbyterian Church can be seen.

During the decade of the 1870s, Muskingum produced two famed educators, William Rainey Harper, the founder of the University of Chicago, and William Oxley Thompson, noted president of the Ohio State University. Harper was a child prodigy and excelled in languages of antiquity, giving his valedictorian speech in Hebrew at the age of 14. Harper's father contributed a significant sum for the construction of Paul Hall. William Rainey Harper is pictured here.

William Rainey Harper married Ella Paul, daughter of Muskingum president Rev. David Paul. In a letter, Harper wrote to his aging father-in-law of his concern for his financial situation, offering him money and urging him to move to Chicago to take a position at the university. This is a view inside the Harper Cabin, which is now owned by the college.

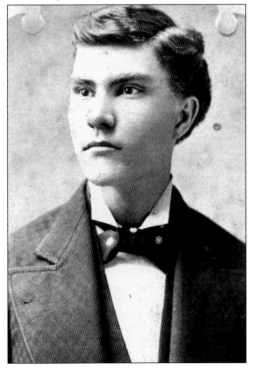

Pictured here is William Oxley Thompson during his years at Muskingum, where he received his bachelor's degree in 1878, and later his master's in 1881. He went on to the Western Theological Seminary in Allegheny, Pennsylvania. In 1885, he traveled west to serve as a minister for a presbytery in Colorado.

Before serving as president of the Ohio State University, Thompson was also president of Longmont College of Colorado and Miami University of Ohio. However, it was his 26 years of service to the Ohio State University, from 1899 to 1925, that he is most noted for. His progressive ideas helped build the Ohio State University into the institution it is today. In his honor, the main library still bears his name. (Courtesy of the Ohio State University Archives.)

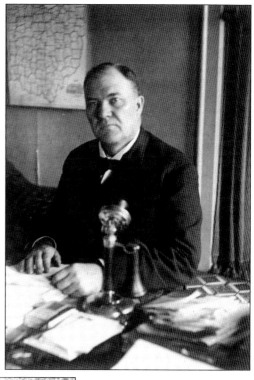

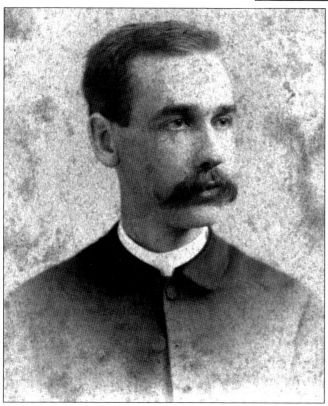

Another noted graduate of Muskingum was Melvin Grove Kyle, class of 1881. He went on to become the president of Xenia Theological Seminary, which later became part of Pittsburgh Theological Seminary. Kyle was also an established archaeologist. Many of his published works on archaeology in the Holy Land are still in print.

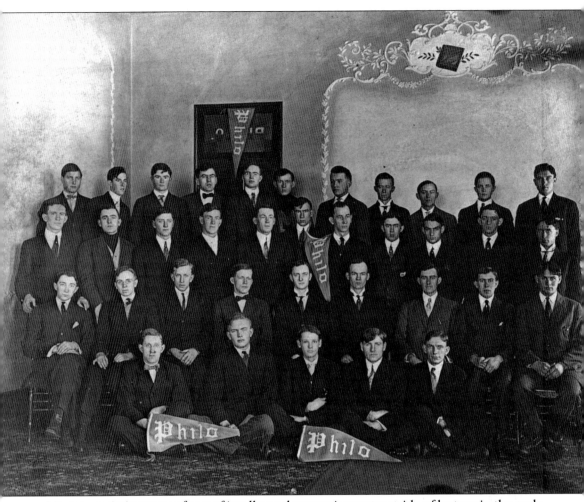

Literary societies were a form of intellectual entertainment outside of lecture in the early years of the college. Pictured here is the Philomathean Society, Muskingum's second-oldest society, founded in 1846. The location of this picture is on the second floor of Johnson Hall, sometime after 1899, and the decorative scrollwork was still on the walls when the building was demolished in 2008. The Philos, as they were commonly called, were founded by a group of 11 students that included future president Rev. David Paul and Nicholas Pascal. Pascal arrived at Muskingum College from Vera Cruz, Mexico, in the midst of the U.S.-Mexican war. Just how and why Pascal journeyed from Vera Cruz to New Concord is a mystery, but he was probably the college's first foreign-born student. The Union Literary Society, the rival of the Philomatheans, was founded in 1836 by students of Andrew Black's academy and their fathers. The window transom in the background of the picture, with the painted letters "PHILO," and one marked "U.L." for the Union Literary Society, have been preserved as reminders of Johnson Hall's important place in the history of the college.

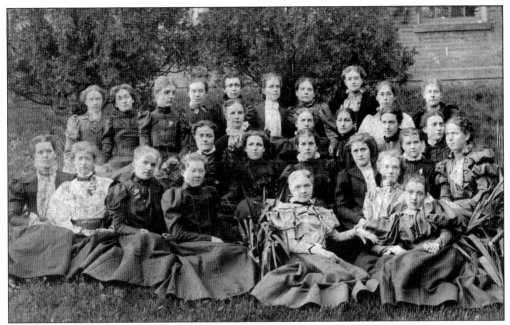

Muskingum also had literary societies for women, who were first admitted to the college in 1851. The Erodelphian Society was founded first but folded after a few years. In the 1880s, a second women's society was formed when Pres. F. M. Spencer ordered the removal of female members from the Philomathean Society, creating the Aretean Society. Above are the Aretean members in 1898. The Erodelphian Society would be revived in 1910.

Each of the literary societies secured its own meeting hall within the college. Beginning in 1843, the Union Literary Society met in the east room of the old college building until it burned, while Philomatheans met in the attic. When Johnson Hall was built in 1899, the societies began to meet in the rooms on the second floor. Aretean Hall is pictured here as it looked at the dawn of the 20th century.

ANNUAL CONTEST

OF THE

Philomathean & Union Lit'ry Societies,

OF MUSKINGUM COLLEGE.

THURSDAY EVENING, MARCH 25, 1858.

ORDER OF EXERCISES.

MUSIC—PRAYER—MUSIC.

INTRODUCTORY ADDRESS,....................R. W. HILL, Fostoria, Ohio.

MUSIC.

ESSAYS.

WE MUST THINK FOR OURSELVES................J. S. SPEER, Cassel, Ohio.
BETHLEHEM'S STAR.................J. A. MCKEE, Chandlersville, Ohio.

MUSIC.

ORATIONS.

INDUSTRY,.......................J. R. BOYD, Guernsey County, O.
THE CROSS AND CRESCENT,......A. S. MILHOLLAND, New Concord, Ohio.

MUSIC.

DISCUSSION.

Is the love of honor a greater incentive to duty, than the fear of punishment?

AFFIRMATIVE...........................W. G. MOOREHEAD, Union, Ohio.
NEGATIVE........................J. H. BUCHANAN, New Concord, Ohio.

MUSIC.

DECISION.

MUSIC.

BENEDICTION.

Times Print, Cambridge, Ohio.

Each society met on Friday evenings to discuss and debate topics relevant to society as well as some dealing with religion and morality. In addition, they engaged in debates with one another over topics such as "Should the Missouri Compromise be restored?" "Should foreign immigration be prohibited?" and "Should vendors of ardent spirits be punished with imprisonment?" Each society also maintained its own library, which were important supplements to the small college library during the lean years of the late 19th century. But the activities of the literary societies did not always remain in the realm of intellectual discourse. The rivalries encouraged pranks as well, such as when the Philomathean Society managed to steal the Union Literary Society's stove in the winter of 1866.

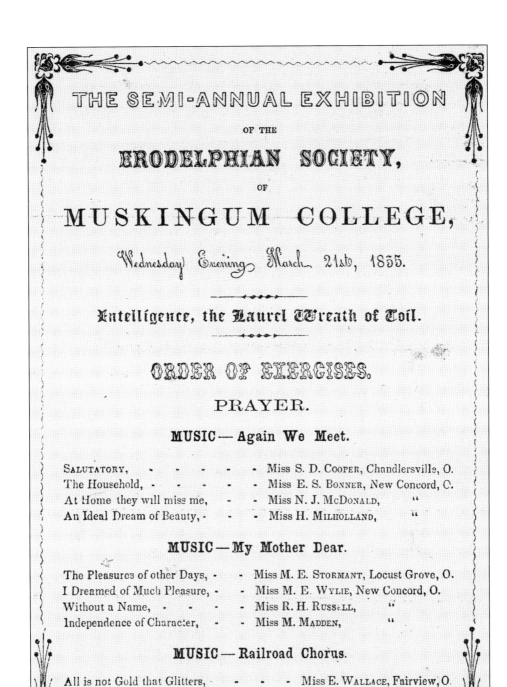

Unlike the male societies, the female societies did not emphasize competition. Their exhibitions reflected the views of the roles of women and their talks centered on sentimental topics. As seen in this Erodelphian program, music also played an important role in these intellectual gatherings. Membership in a literary society was compulsory for both sexes for many years until the 1920s when loyalties began to shift to the emerging social clubs.

In the 19th century, Muskingum had no dormitories. Students were housed and fed for a fee by families who lived in New Concord and the surrounding area. The houses where students roomed and boarded were called forts. Sharing a meal around a common table with the same small group each day was one way in which the college strove to preserve the experiences of home-life for their sometimes homesick charges. Pictured here are the ladies of Fort Martin in 1904.

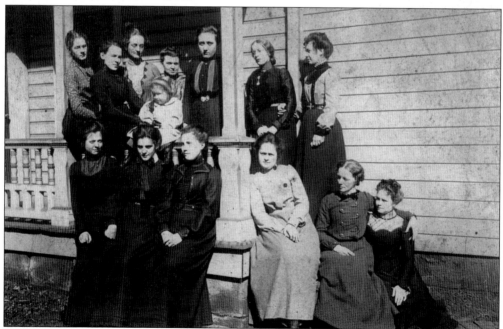

Pictured here are the ladies of Fort Herdinau. From left to right are (first row) Rata McMunn, Ethel Nelhelm, Eleanor Nylie, Zelda Buchanan, Maude Bethel, and Flora Wallace. The second row includes Rosa Alice Pugh, Janet Knerr, Elnora McMann, Emma "Herdie" Herdman, Mary Patterson, Bertha Bethel, and the child is baby Ruth Nelson.

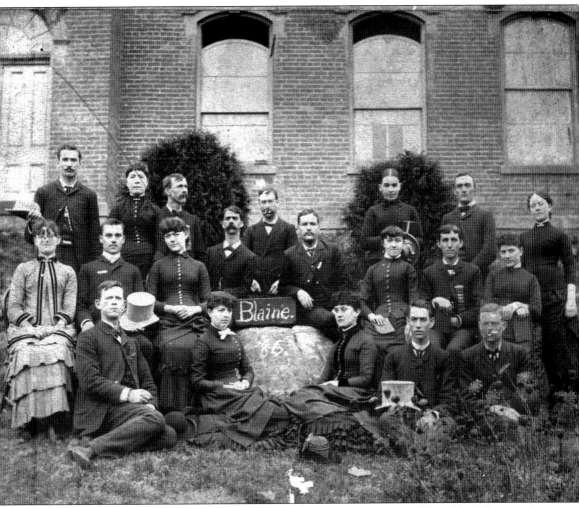

While other parts of Muskingum County had Democratic sympathies, New Concord and the college community were staunchly Republican. Here members of the college Republicans show their support for presidential candidate James G. Blaine in 1884. It is interesting to note that 9 of the 20 members of the club are women, at a time when neither major political party endorsed woman suffrage, and just two years after college president F. M. Spencer ended the Philomathean experiment of coed literary societies. The rock in the middle of the picture still rests in front of Paul Hall and bears the weathered inscription of the official motto of the class of 1880, "In God We Trust."

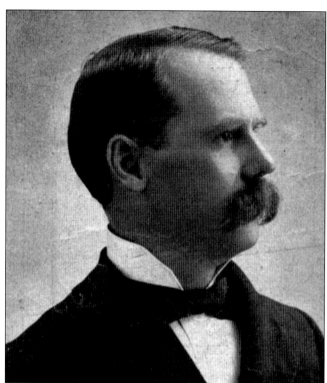

Rev. Jesse Johnson's presidency, between the years of 1893 to 1902, began as temporary professorship. Cramped conditions had continued to plague the college during the presidencies of F. M. Spencer and J. D. Irons. Some classes were held in the town hall due to the lack of space. The board authorized the construction of a new building on the condition that New Concord contribute $2,500 to its $10,000 cost. The village responded quickly, and in 1899 the "new building" was completed.

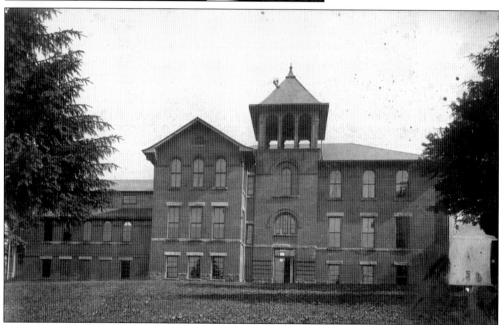

Like its predecessor, it did not receive the name Johnson Hall until much later, a tradition that would continue for many decades to come. In 1902, President Johnson resigned his position to accept a professorship at Xenia Seminary. President Johnson's departure from the college would mark the beginning of a two-year search for a president: the man who would follow him would forever reshape the future of the college on the hill.

MUSKINGUM COLLEGE,
NEW CONCORD, OHIO.

Report of _DuBois, D. D._

For _Winter_ term of 1897.

STUDIES	GRADE		ABSENT	
	CLASS	EXAM	TIMES EX.	TIMES UNEX.
Chemistry	91	96		
Political Econ.	92	97		
General Geometry	92	100		
Phil. of Rhetoric	92	95		

ABSENT from PRAYERS. | EXCUSED. | UNEXCUSED.

Remarks. _I am not much given to "taffy", but I want to say to you that this young man is all right_

SCHOLARSHIP. J. J.

Grading is on the scale of 100. If the class grade is less than 70, the study must be taken again. If the examination grade is less than 65, another examination must be taken (after private review) or study taken again, at the discretion of the professor.

JESSE JOHNSON, President.

This report card of D. D. Dubois is signed by President Johnson. Johnson seemed to think very highly of this particular young man as is evident in his comments. Worship was also an important aspect of a student's education in the college. Attendance was taken at services led by members of the faculty. Illness was the only valid excuse for absence during chapel.

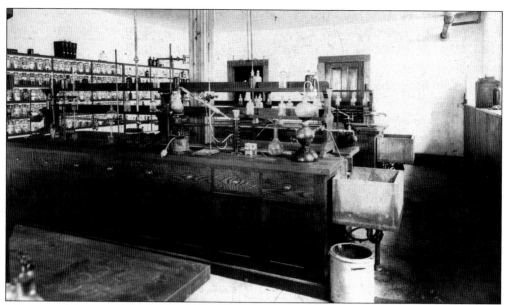
Johnson Hall was built at a cost of $10,659, with an additional $2,100 raised for additional details. The sciences also found a new home in the basement of Johnson Hall. Biology was taught in this room.

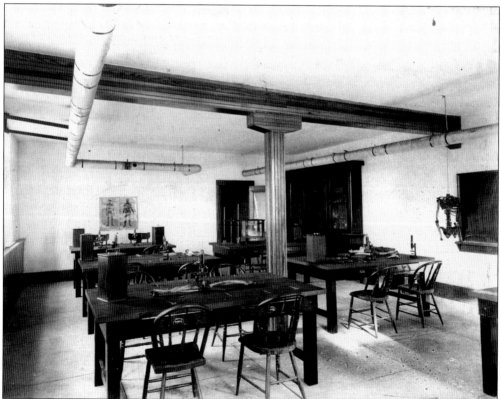
This was a chemistry classroom in the new building. The upstairs rooms would become home to the literary societies. The college infirmary was also housed in the building.

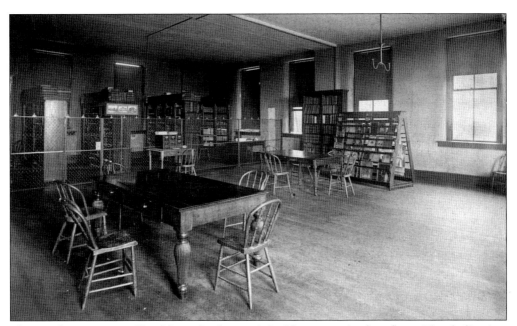

The newly constructed building also housed the library on the first floor. The dedication of Johnson Hall took place at 2:00 p.m. on June 21, 1899. Prof. T. H. Paden, who played a key roll in organizing the dedication, was a professor of language who began teaching at Muskingum in 1874. He was among the first professors that were not clergymen.

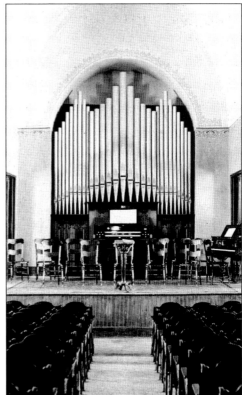

Johnson Hall also included an auditorium equipped with a pipe organ, which was installed 1909. Various plays, shows, debates, and religious services were hosted in this room. The pipe organ remained in the building even after it no longer served as the college's main auditorium.

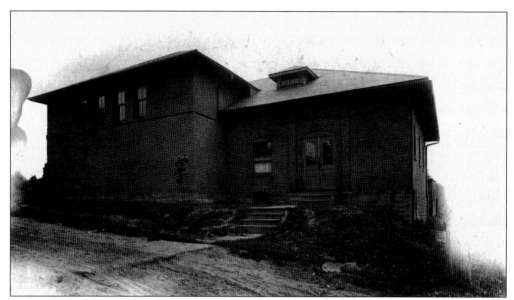

The intercollegiate athletics movement began to build steam just before 1900. Muskingum College faculty urged the trustees to build a gymnasium, and the old portion of Paul Hall, still deemed a fire hazard, was torn down and its bricks used to construct the Alumni Gymnasium, so named because students and alumni raised the necessary $4,492 in 1900. The tiny building would later serve as the Little Theater, a moniker reflective of the building's diminutive capacity.

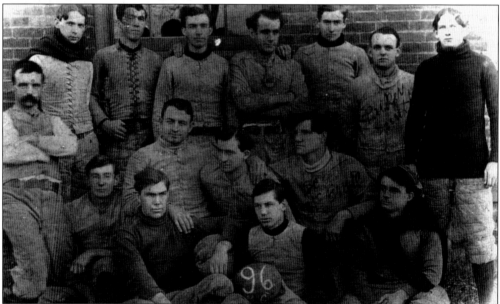

Football began at the college when forts (eating clubs) would gather to play one another. The sport became more organized in 1895 when a team was formed. The schedules in the early years were inconsistent, made up of some collegiate and noncollegiate opponents, like the Zanesville Athletic Club, which Muskingum beat soundly in all three of their first matchups. Pictured is the 1896 team, Muskingum's second-recorded football team, and the oldest known surviving photograph of a Muskingum College team.

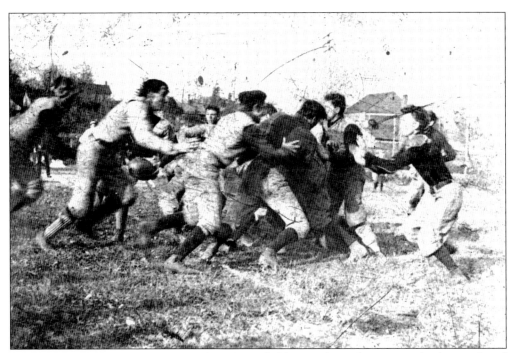

Muskingum's home games were played in a field near the Baltimore and Ohio Railroad tracks that the college purchased for athletics. This picture is from Muskingum's October 14, 1899, competition with Denison, which was won 6-0. The team would finish 1-4 that year recording two losses to Ohio State, one to Marietta, and in their rematch against Denison.

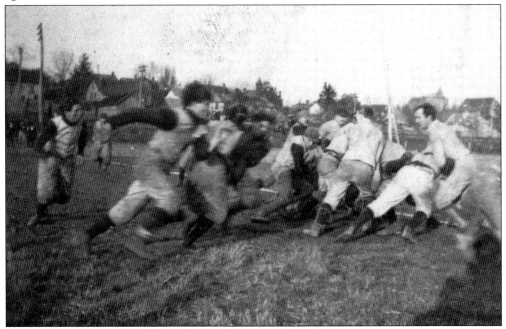

Here is another early photograph of the Muskingum squad in action. Football sparked a growing sense of pride for their school among the students.

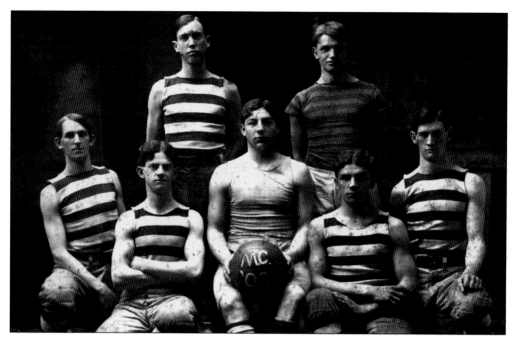

Basketball also began to emerge as a popular sport. This 1903 squad's members were listed on the back as "Cleland, O. McKinney, P. Carson, Johnston, Edgar, Shipley, W. Carson." Like the football team, the basketball team's first opponents were often local clubs. The 1902–1903 season is the oldest for which a record of their play is known to survive.

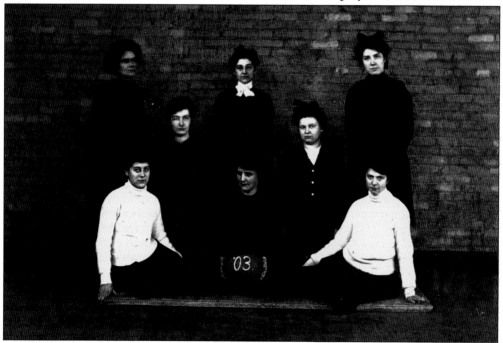

Basketball was also played by the college's female students. This group photograph from 1903 includes "Cook, the coach, McMunn, Cowden, Cleland, Caruthers, Lorimer, and Wylie."

Two

BUILDING FOR THE AGES
1904–1931

The leadership of college presidents David Paul and Jesse Johnson, and the strong support of New Concord residents, saw Muskingum College through the lean years of the late 19th century. When J. Knox Montgomery was called to the presidency in 1904, the "campus" of Muskingum College consisted of the two buildings later known as Paul and Johnson Halls and the new and diminutive Alumni Gymnasium. The dusty, isolated village of New Concord remained a place where city luxuries did not yet exist. The energy and vision of J. Knox Montgomery would transform Muskingum College over the next quarter century. Enrollments quadrupled during the first 20 years of the 20th century, and the college would respond with an impressive building campaign that would see the center of college operations shift westward from the historic east campus.

The student body would also experience a gradual but significant change, as the college moved beyond its Presbyterian core and students developed vocational interests beyond teaching and the ministry. To be sure, Muskingum College retained its conservative Christian identity, and as late as 1933 a Youngstown newspaper would describe New Concord as "The College Town That Sin Forgot," but the youth culture that emerged in the cities and the automobile would bring change to Muskingum College in small ways. Prohibitions on alcohol, tobacco use, card playing, and dancing remained in place during the J. Knox Montgomery years, but by the mid-1920s, students began to voice their dissent. The automobile gave students a degree of mobility that allowed them to escape the restricting confines of New Concord and made it increasingly difficult for the college to enforce its behavior codes.

Student social life also changed in significant ways in these years. The old literary societies began to die out, and class rivalries, embodied in new traditions like the freshman versus sophomore scrap day competition, intercollegiate athletics, and the new "social clubs" began to play a larger role in shaping student identities and loyalties. The social clubs were social fraternities and sororities in all but name, but the Muskingum College Board of Trustees retained the ban on those kinds of organizations throughout the era. Nevertheless, by the end of the 1920s, fraternities and sororities were the most important social outlet for a majority of the students on campus. The YMCA and YWCA remained strong throughout the era and remained the president's preferred organizations for overseeing student social activity.

Muskingum's search for its next president was a long one. R. A. Hutchinson, the trustees first choice, turned down the position and the position fell to a minister preaching in a Charlotte, North Carolina, church, Rev. J. Knox Montgomery. Montgomery's dream for what the college could become was ambitious. He imagined Muskingum as a regional institution that would draw in students from all over southeastern Ohio, as well as Columbus and Pittsburgh.

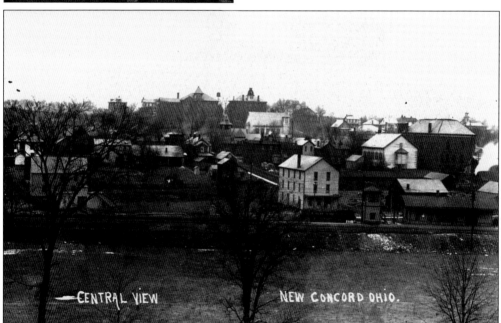

The New Concord that Montgomery came to in 1904 was one far different from that of today. Muskingum lacked electricity, indoor plumbing, and paved roads. This view of New Concord was taken a few years after his arrival. Montgomery was determined to modernize the institution and to raise academic standards. Among other reforms, he increased the size of the faculty and began the practice of assigning credit hours to courses.

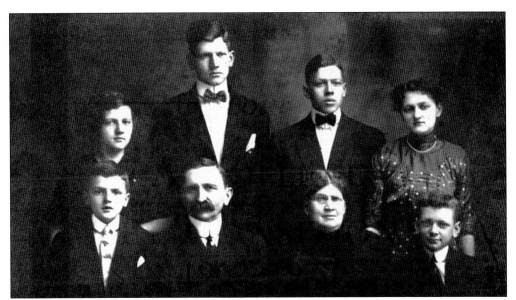

The Montgomery family had a great impact on Muskingum College. Pictured here from left to right are (first row) Paul Montgomery, J. Knox Montgomery, Emma Patton Montgomery, and Robert N. Montgomery; (second row) Geneva Montgomery, J. Knox Montgomery Jr., Don Montgomery, and Grace Montgomery. Not only did the men of the family become pillars of the college, Geneva was one of the founders of the Delta Club in 1918.

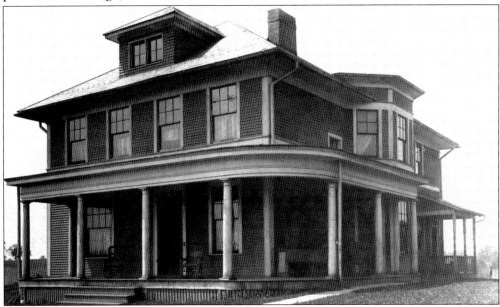

One of the conditions of J. Knox Montgomery's employment was that the college build a manse to house his family. Completed in 1905, the manse received a brick facade in the 1920s. Throughout its early history, Muskingum had struggled to keep afloat financially. Montgomery set out to remedy that through the Half Million for Muskingum and later A Million for Muskingum campaigns. The generosity of two Pittsburgh women, Christine Arbuckle and her sister Mrs. Jamison, whose support he ensured, kept the college alive.

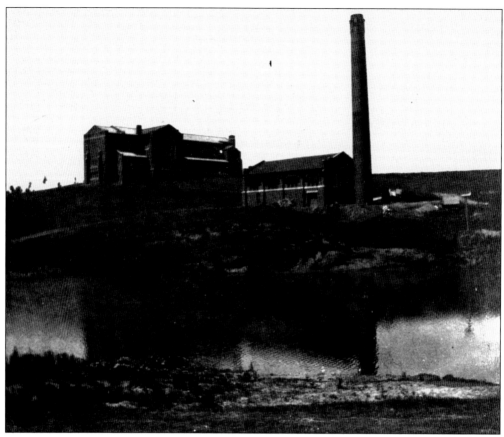

Under J. Knox Montgomery's leadership, the college purchased 11 acres of land to the west of the small campus and began "to build for the ages." The chapel opened its doors in 1912 and would be named in honor of J. M. Brown of Wheeling in 1919. The power plant, which was completed in 1914, provided electricity not just for the college but for many years supplied the village of New Concord as well.

In 1913, the college purchased additional land north of Old Campus to become the college lake. Shocks of corn and grazing cattle can be seen here on the site in 1904 before the valley was dammed up and flooded.

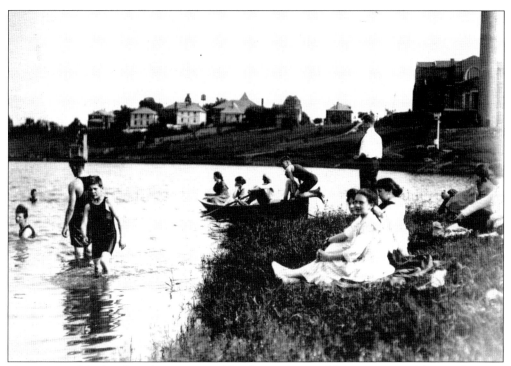

The campus lake has long been enjoyed by the students of the institution. The Muskingum Academy students pictured here enjoy boating. Swimming was also a popular pastime during this era. Floating platforms, slides, and diving boards once adorned the lake.

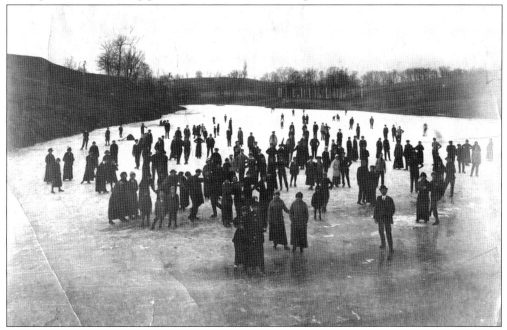

Recreation was not limited to the warmer months. Once cleared as safe by the college engineer, students ventured onto the ice to skate. The man standing alone, wearing a hat, in the bottom right corner is college president J. Knox Montgomery.

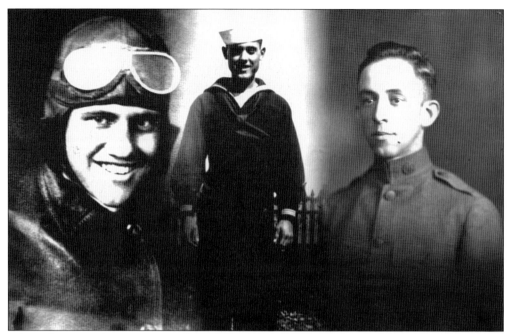

When the United States entered World War I, many Muskingum students answered the call. By October 1918, 155 Muskingum College students were in military service. Pictured here, from left to right, are R. W. Gibson, class of 1918; E. E. Grice, class of 1919 (U.S. Navy 1917–1919); and Sgt. Paul Murphey, class of 1913, who served in the 308th Field Signal Battalion and the Headquarters of the Third Army Corps.

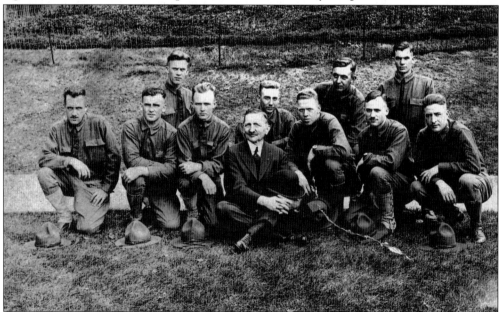

Most of the Muskingum College students who enlisted in the army were sent to Camp Sheridan in Alabama. The *Black and Magenta* regularly reported updates on former students, and J. Knox Montgomery made a special trip down to Alabama to encourage the Muskingum men in 1918.

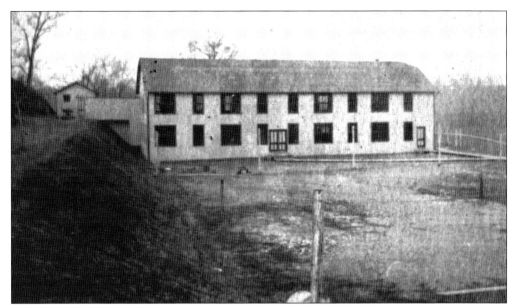

The Student Army Training Corps (SATC) barracks are seen on campus in 1918. SATC cadets would be enrolled at Muskingum College while receiving their military training. To house the large numbers who applied for the program, the college built these barracks, which were occupied only briefly before the end of the war saw the disbanding of the SATC program. After the war, the barracks were converted to a much-needed gymnasium.

The arrival of the U.S. Army on Muskingum's campus resulted in a clash between the college's strict regulations on student behavior and the army's more tolerant attitude. Montgomery was determined not to allow these special circumstance undermine enforcement of behavior codes, and after some modest resistance, the army relented. Muskingum College's SATC would be expected to refrain from swearing, smoking, drinking, and card playing while they were on campus.

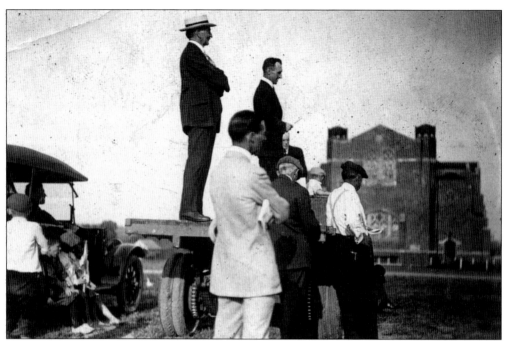

When the guns of Europe ceased to fire, J. Knox Montgomery was able to begin work on what he envisioned Muskingum would become. Montgomery purchased 11 acres west of campus in 1909 to become home to the expanding campus whose student population ballooned after the dawn of the 20th century. Montgomery is seen here presiding over the groundbreaking of Montgomery Hall, which was completed in 1920.

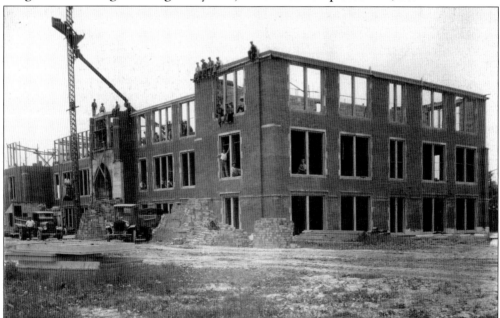

Here workers pose for a picture as they work on what would later come to be known as Montgomery Hall. Built at a cost of $200,000, it was to become the first of many buildings on the academic quadrangle that was envisioned by J. Knox Montgomery.

Montgomery Hall provided the growing campus with much-needed classroom space. The new building would also house the administrative offices of the college. With this expansion, Johnson Hall became dedicated to housing the sciences and the library while Paul Hall housed the college preparatory program, the Muskingum Academy.

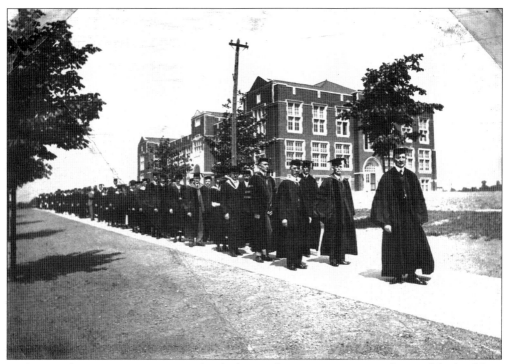

In this 1924 picture, Montgomery leads the academic procession in front of the building that would eventually be named in his honor.

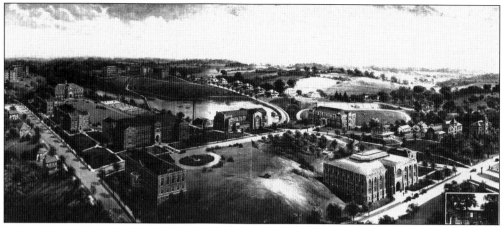

J. Knox Montgomery had big dreams for Muskingum. In this vision of the future campus proposed by the president, there were to be twin science buildings, Cambridge Hall and Zanesville Hall, with funds raised from the citizens from both towns. The building to the bottom right was to be the Guernsey-Muskingum Library, built through funds from the Andrew Carnegie Foundation and the citizens of those two counties, for use by both the college and the public.

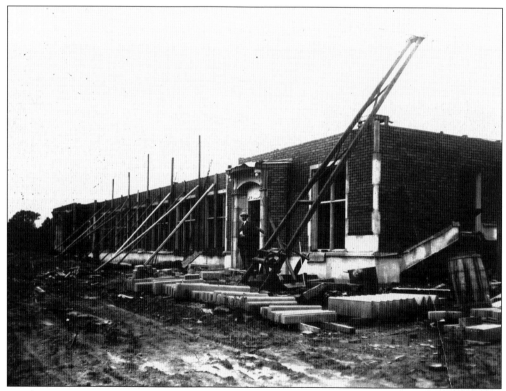

Work on Montgomery Hall had barely been completed when Montgomery set out on his next endeavor to expand the institution. Plans had been in place for the building of a dormitory for women for at least a decade. At the end of spring vacation 1922, 80 girls moved into the new facility.

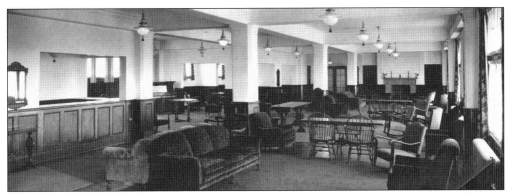

The dormitory for women was well equipped and furnished. The first floor provided the ladies with a spacious lounge, as seen here. Many decades later the building would be named Patton Hall, after J. Knox Montgomery's wife Emma Patton Montgomery.

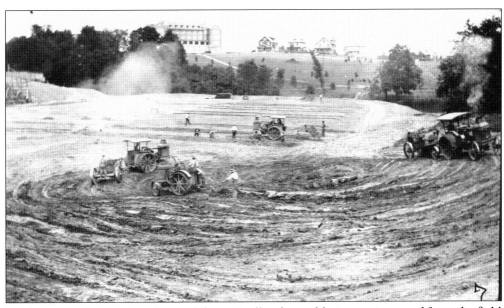

Muskingum athletics also changed dramatically when athletic events moved from the field by the railroad tracks to a new stadium on campus. College engineer "Cam" McConagha oversaw its construction. McConagha began his career at Muskingum as a janitor but eventually came to be known by the president and the rest of the college as the "wizard" of campus for his ability to get things done. Here tractors grade the field.

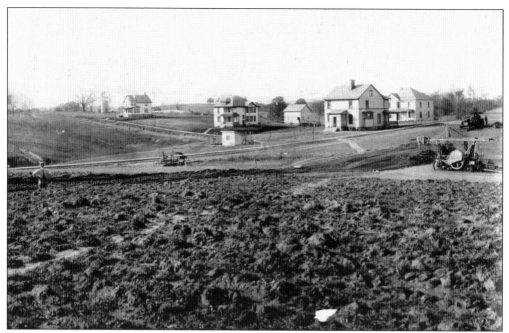

The face of the college changed again with the addition of Cambridge Hall, so named for the financial contributions from many groups and individuals of that town. Here workers grade the site before construction. Note how few houses there are on Montgomery Boulevard.

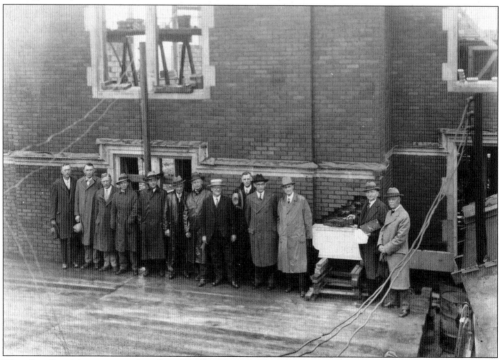

The fund-raising campaign for Cambridge Hall, which would house geology, chemistry, and physics, began on January 28, 1924. The building opened in 1928.

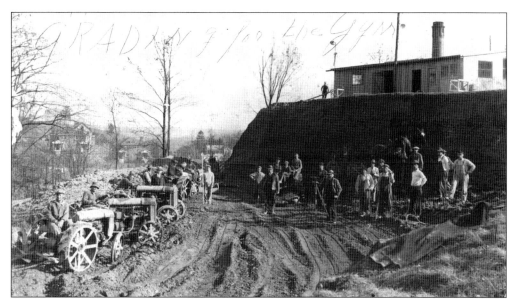

Tragedy struck on August 29, 1928, when the old barracks from World War I, which had since served as a makeshift gymnasium, burned to the ground. Construction on a new gym commenced soon after but would come to a halt with the onset of the Depression.

Pictured here is the memorial to the class of 1922, which no longer exists. It was located near the power plant. Other memorials include the sidewalks in front of Johnson (1915), the former college entrance (1918), the old stadium steps (1925), and the campus spring (1914). The stone in front of Paul Hall is the oldest surviving memorial, a gift of the class of 1880.

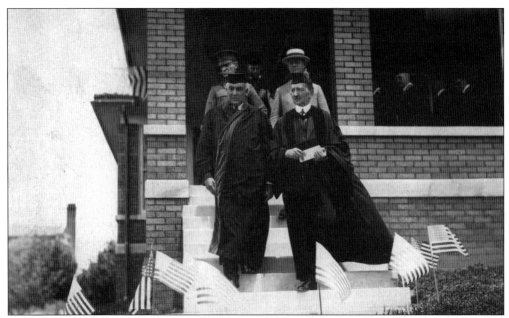

The college bestowed an honorary degree to Pres. Warren Harding on July 7, 1922. Harding had attended Ohio Central College, a college founded by an ardently antislavery sect of Presbyterianism. When that college folded in 1885, Muskingum assumed its records and alumni. Harding's visit was a grand spectacle; the ceremony took place at the natural amphitheater at the college spring. Harding is seen here descending the steps of the manse with J. Knox Montgomery.

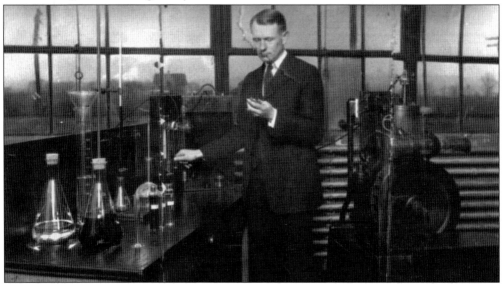

Thomas Alvin Boyd attended the Muskingum Academy and summer teacher training courses for four terms in 1907 and 1908 and described it as "one of the most pleasant and profitable periods of my early life." Boyd went on to become a leading chemist for General Motors, and he was among the earliest proponents of cellulose-based biofuels for automobiles. In 1990, the science building was renamed in honor of Boyd and his wife Grace Bethel Boyd, class of 1915.

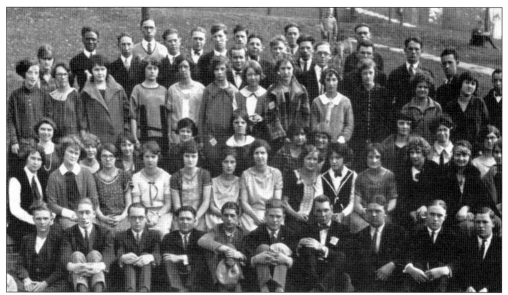

Ethiopian student Melaku Bayen is pictured in the top row, far left, of this 1925 Muskingum Academy senior class picture. Bayen went on to become the personal physician of Emperor Haile Selassie and the founder of the Ethiopian World Federation. Working with African American political and cultural leaders, Bayen brought the story of Ethiopia's courageous resistance to the Italian fascism to the world. He is considered a seminal figure in the pan-African and Rasta movements.

Students were expected to attend the Sunday night vespers. If the weather was pleasant, services were held outside. This picture was taken in 1921. President Montgomery believed strongly in the importance of Christian education. He also took up moral crusades against vice as president of the National Anti-Cigarette League and even ran for governor as a Prohibition Party candidate.

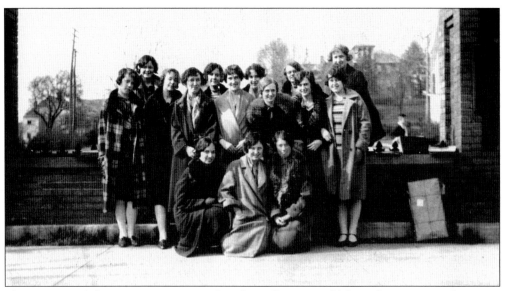

The YWCA and the YMCA were central to the college social life in the 1920s, and J. Knox Montgomery saw them as an antidote to the emerging youth revolt. However, this particular YWCA executive board of 1927 was disciplined for allowing dancing at its socials. Pictured from left to right are (first row) Helen Pinkerton, Dorothy White, and Ruth Davidson; (second row) Helen Daugherty, Jane Wilhe, Julia McKibbben, Ferne Layton, Ruth Thompson, Lois Brownlee, Evangeline Giffen, Lincoln McConnel, Margaret Kelsey, Ruth Thompson, Helen Brownlee, and Bertha Barland.

The college chapter of the YMCA poses in front of the college spring. Almost all students participated in the YMCA or YWCA during these years; it was the center of student social life before the emergence of fraternities and sororities.

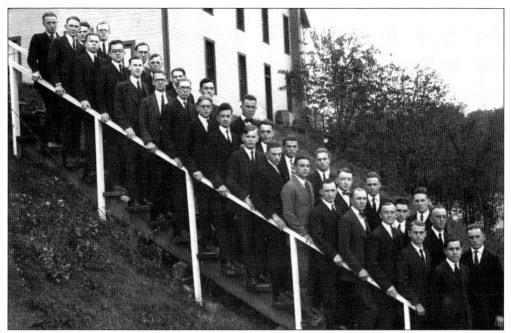

Gospel Team was a men's group that helped with services in area churches. The building in the background was originally used for soldiers during World War I and afterwards as a gym.

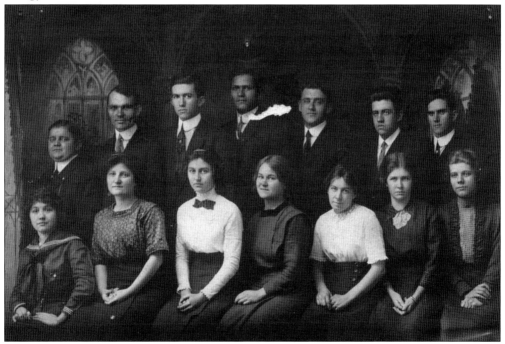

The Student Volunteer Movement for Foreign Missions was another important student group in this era. The college was very involved in global missionary work, and that involvement created an international awareness that stood in contrast to the prevailing isolation of the years between the wars. This picture is from the 1915 yearbook.

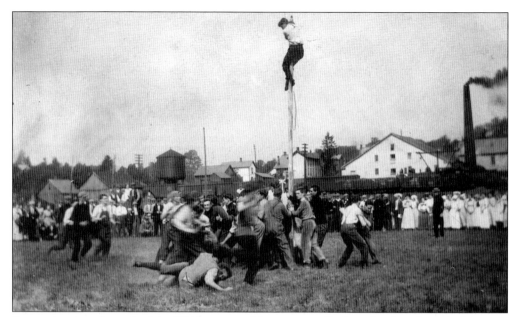

Scrap day was launched in 1910 to provide a controlled outlet for the mischievous energies of students. The day's activities included a series of competitions between the sophomore and freshman classes, while the juniors and seniors cheered them on. Pictured here is a flag pole rush, in which each class raced to remove the other class flag from a greased pole.

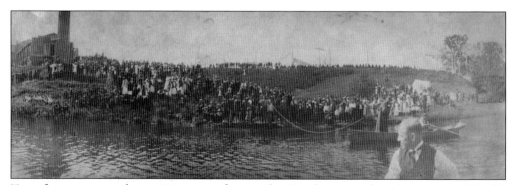

Tug-of-war was another main event of scrap day. Freshman and sophomores originally competed over Crooked Creek until the creation of the college lake. Football and wrestling were other events that were part of this great tradition.

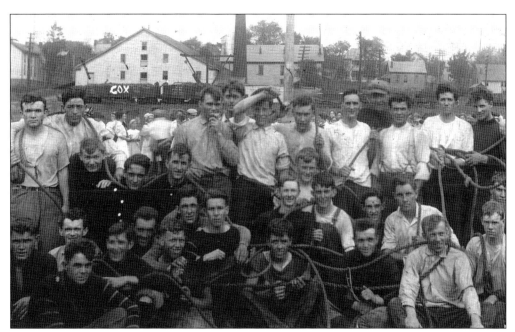

Before the creation of a field for athletics on campus, scrap day and other activities took place by the train depot. The scrap day winners of 1912 are pictured here with the tug-of-war rope. After a winner was declared, seniors hosted a social for sophomores, and juniors hosted one for the freshman.

Bum day was also an event that was a highlight of this era. It began as pig tail day and only girls partook in the event. Eventually the males joined in too. On bum day, students dressed in outrageous mismatched and out-of-fashion outfits such as these. Prizes were awarded for the worst dressed students after 1922.

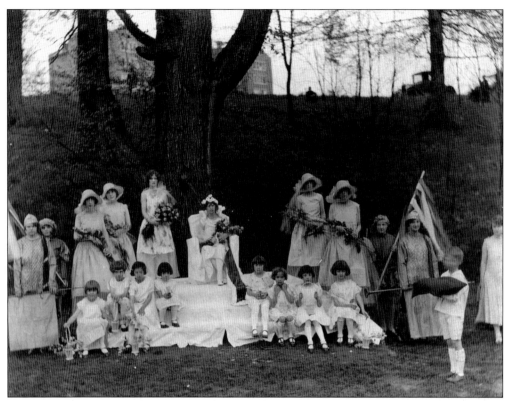
Students celebrated the arrival of spring in one of the most popular annual traditions, the May Day festival. The women's physical education instructor was in charge of this event, and its events were part of the physical education program for women. This is a picture of the May Day court.

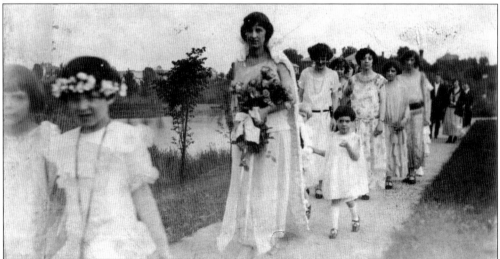
May Day festivities included a formal procession of all the lords and ladies of the court, and people dressed as animals and other characters to welcome spring. A member of the senior class would be chosen to fill the role of May Queen. One of her major duties included leading the procession of the court to their positions.

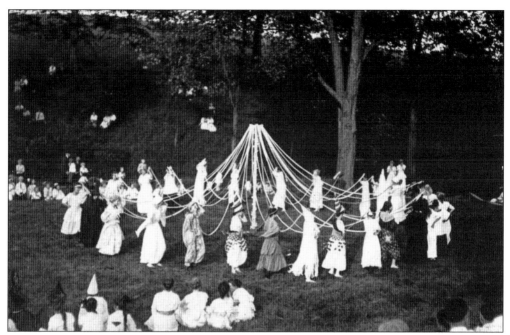

May Day festivities drew crowds from nearby Cambridge and Zanesville. Spectators laid out blankets on the hillsides of the hollow to watch the traditional maypole dance.

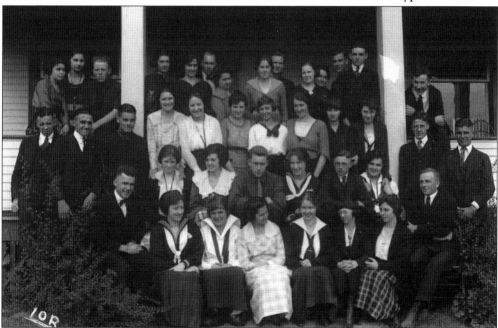

Libbia Sleeth Giffen and her sister Mable Esterquest opened Fort Giffen to boarding students after the death of Giffen's husband in the 1918 flu epidemic. Taking in student boarders was a common way unmarried or widowed women could earn a living during these years. The fort enabled the widow Giffen to put all five of her children—and herself—through Muskingum College. She graduated with her youngest son with a degree in special education.

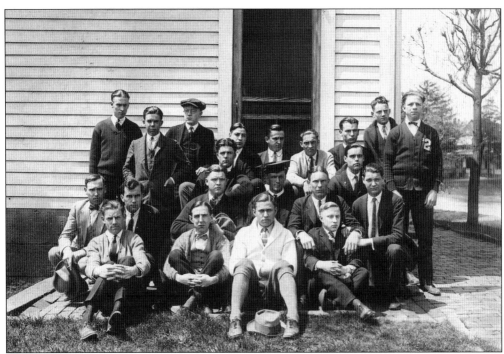

Pictured here are the 1924 residents of Fort Thompson. Forts served as surrogate families and also as the basis for light-hearted rivalries. In the 1922 *Muscoljuan*, members of Fort Thompson proudly declared "We like to talk, We like to eat. For these Fort Thompson Can't be beat."

The three McGee sisters operated a fort they called Faith, Hope and Charity.

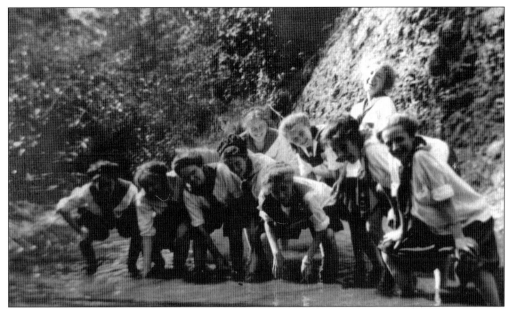

The day-to-day lives of the students were not wholly consumed by study and religious activity but they were dominated by the rigid piety demanded by the president. Students, however, were granted a few more freedoms than they had had during the 19th century. These young ladies enjoy wading in Crooked Creek. The school also sponsored a women's hiking club as part of the physical education program.

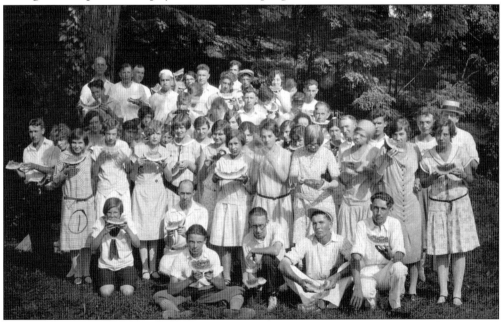

Picnics, often sponsored by one of the many organizations on campus, were also enjoyed by students such as these who are savoring watermelon. Among the clubs that existed in this era were clubs organized around specific vocations, such as the Future D.D.'s (doctors of divinity) for preministry students and others organized based on where students were from such as the Keystone Club for Pennsylvania students.

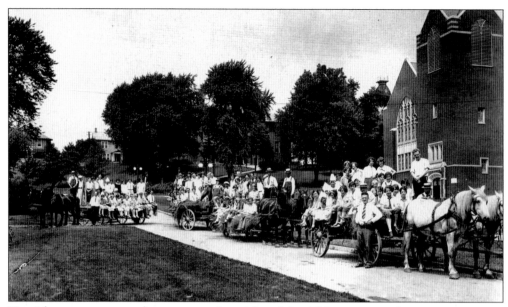

Hayrides were yet another approved social activity. This caravan of wagons poses on College Drive in front of College Drive Presbyterian Church. Alcohol, tobacco, card playing, and dancing all remained strictly forbidden. Students still needed to request permission from a faculty member before leaving the village.

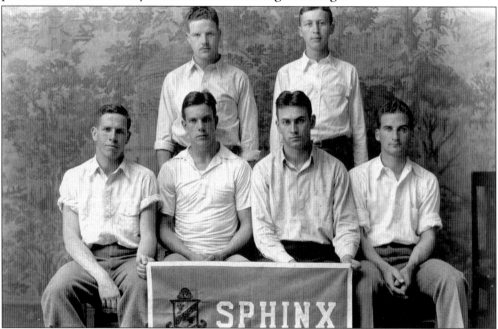

During J. Knox Montgomery's tenure as president support for the literary societies had waned and they ceased to exist after 1923. Students began to identify themselves with the newly emerging social clubs. The first was the Stag Club in 1909, followed by the Sphinx Club, pictured here, in 1910. Members of the eating club Fool's Mansion would form the Stoic Club in 1918. The early clubs were careful not to be identified as fraternities which were strictly forbidden by the trustees.

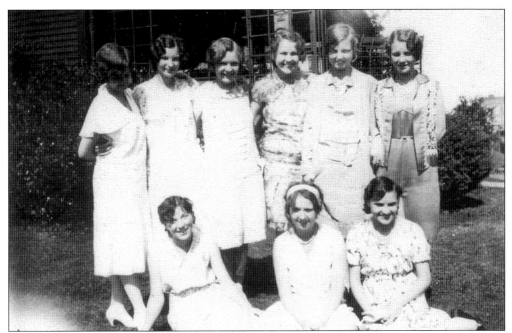

The first women's social club on campus was the F.A.D., founded in 1914 by women from the same fort. Other women's social clubs soon followed: Delta Gamma Theta in 1918, and Wawyin in 1923. Pictured here are the women of Kianu in 1928, a year after their founding in 1927. While the college's behavior code remained very strict throughout the 1920s, the emergence of these new social groups was a sign that student culture was changing. (Courtesy of Chi Alpha Nu.)

Harold P. Finney, the namesake of Finney Hall, is pictured here at the end on the left with his fellow members of MACE. The MACE club was founded in 1922 followed by the Alban club in 1925. While many clubs were founded earlier, it was not until 1925 that they were given their charters by the school. Beginning in 1923, the clubs were required to have a faculty member serve as their advisor.

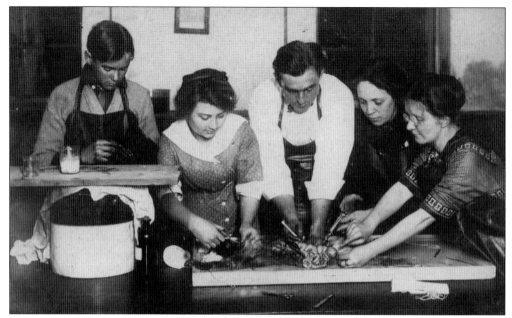

Here students dissect a cat. The J. Knox Montgomery years witnessed a broadening and diversification of the curriculum as the philosophy of progressivism began to reshape college education.

Here is a class photograph that was taken on the side of the hill where the library now stands. Notice the cannon at the top of the hill. This cannon was from World War I and was discharged to celebrate victory during football games. The tradition of the cannon would end when it was melted down during a scrap-metal drive during World War II.

One of Montgomery's faculty appointments was Dr. Charles R. Layton. Layton's high standards in the debate and oratory programs fostered a forensics program that continues to win national awards to this day. Pictured here from the 1910 team are, from left to right, A. Pollock (who later became a U.S. congressman), Earl Lewis, "Bung" Coffee, and John White. Dr. Layton demanded much from his students, and his discipline led some members of the faculty to protest that he was too harsh.

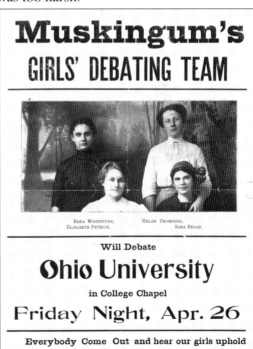

Ferne Layton, wife of Charles, was also an instructor at the college. Working together, the Laytons produced teams that attained national recognition. This flier advertises the women's upcoming debate on the issue of woman suffrage against Ohio University.

The glee club of Muskingum College was able to travel to different parts of the country to sing. These singing groups were started during the late 1920s. It would later become the Beta Lambda chapter of the national men's music organization Phi Mu Alpha.

The marching band became a feature on Muskingum's football field during games in the 1920s. The band's formations included the *M* and spelling out *Muskingum*. In 1927, Dr. T. R. Berkshire wrote the college's beloved alma mater a decade later in 1937. Berkshire made the first attempt at putting a history of the college in print. Berkshire's book was never published but a draft remains in the college archive.

Orchestra, like many other musical groups at Muskingum, was considered a separate entity of the college. The organization was student-led; junior Adolph Pletincks served as director in this picture from the 1930 *Muscoljuan*.

Smaller instrumental and vocal groups were also formed, including this string quartet in 1917. The last names of those pictured include: Walker, Patterson, Melone, and Forsythe. Muskingum even had a mandolin club at one time. The annual violin festival was also a very important music department tradition.

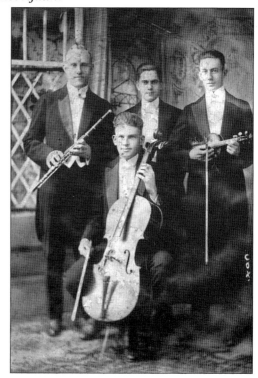

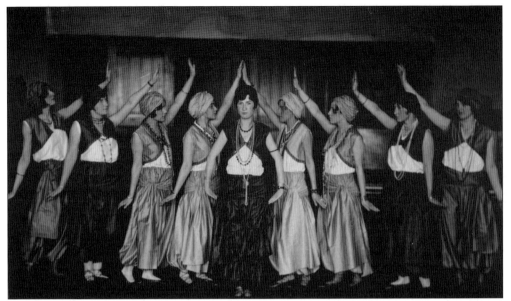

The arts also became an important part of the Muskingum experience in the 1920s and 1930s. This ballet, *Bluebeard*, was performed in Johnson Hall's theater on April 15. The year is unknown.

The junior class presented the Chinese drama *Yellow Jacket* as the commencement play for 1929. The *Muscoljuan* declared that the play was "well received by one of the largest audiences that ever attended a Muskingum play." During the same year, students also produced A. A. Milne's *The Ivory Door*, Ibsen's *The Vikings*, and Shakespeare's *Midsummer Night's Dream*. The French class play for the year was Edoaurd Pailleron's comedy, *Le Monde Ou L'on S'ennuie*.

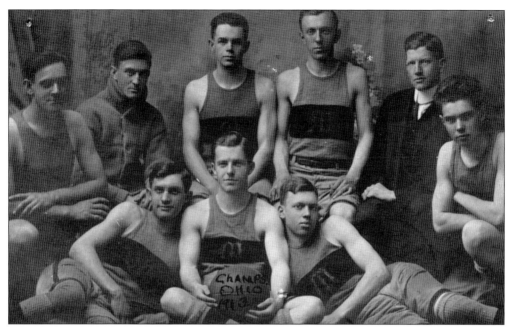

The popularity of team sports continued to grow during the J. Knox Montgomery years. The 1913 men's basketball team won the Ohio Conference. The individual second from the right is team manager J. Knox Montgomery Jr. His younger brother Don was the team captain and is on the right in the front row. The basketball team produced an 8-0 season in 1904–1905, 11-3 in 1912–1913, 11-2 in 1913–1914, 20-4 in 1920–1921, and Ohio Conference championships in 1925–1926, 1926–1927, and again in 1936–1937.

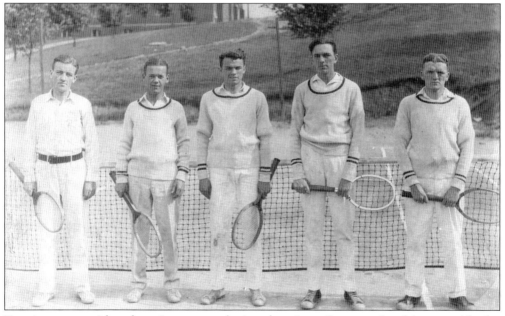

Tennis was considered a minor sport during that time. Courts existed just outside the old Barracks and later at the bottom of Patton Hill near the lake. This is the 1925 team consisting of Post, Best, Smith, Gulfer, and Montgomery.

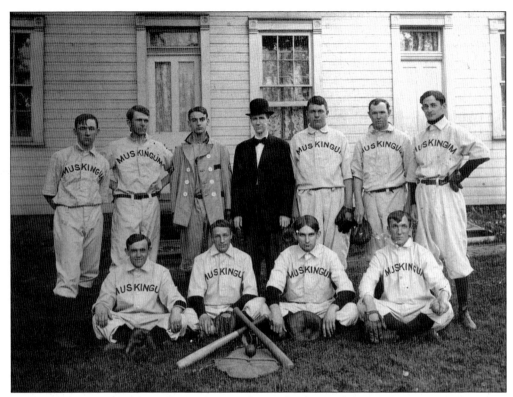

Baseball also grew in popularity during the early years of the 20th century. The 1908 baseball team is featured here with its manager Ray McClenahan. The team went 6-2 that year.

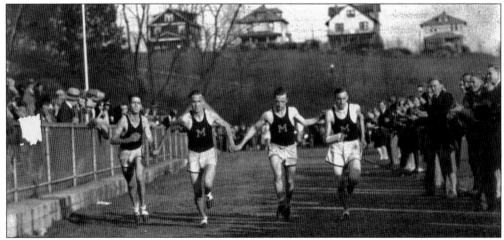

Track and cross-country meets were also popular. Here members of the 1928 team finish a race in front of the stadium built by "Cam" McConagha. Begun in 1926, the Muskingum cross-country team was undefeated in dual meets in its first two years.

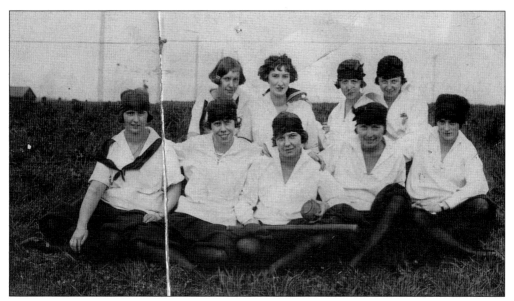

Women's athletics were also important. These ladies are the members of the 1925 sophomore softball squad. Competition in women's athletics was strictly intramural during these years. In 1925, the sophomores were victorious.

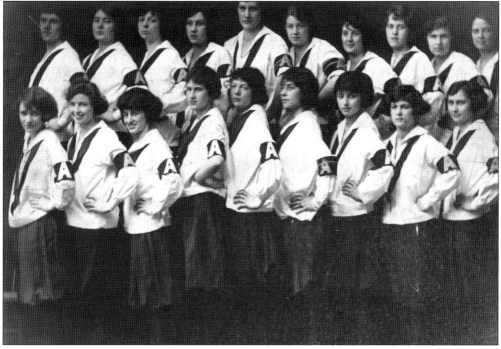

The A Association was formed for female athletes who had earned letters similar to the M Club, which was created for men. A pleasant personality was also a requirement for admittance. Initiates into this organization wore white *A*s until they received full membership, which would allow them to don the red *A*. Red bars were added for each additional year of membership. Agnes Moorehead is pictured first row, sixth from the left, in this photograph from the 1924 *Muscoljuan*.

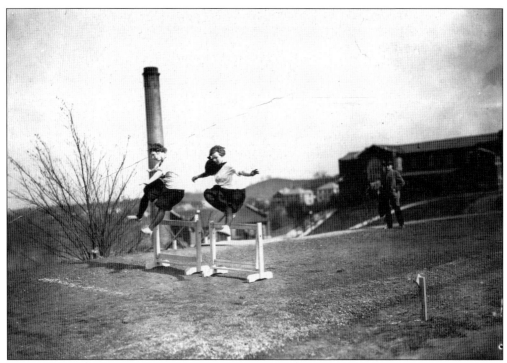

Enrollment in physical education became part of the curriculum for both sexes. The expectations of modesty forced female students, like sisters Elisabeth and Melissa Freeman pictured here, to compete in the hurdles in these baggy "gym clothes."

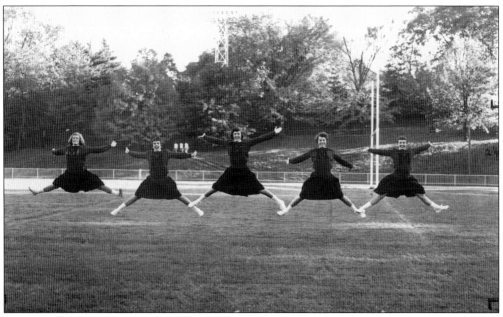

Cheerleading became part of the football game experience. Muskingum's first cheerleaders were male, but eventually women came to dominate the field.

Here fans watch the game from the stands. Prior to 1925, Muskingum's program was not a highly competitive one, but afterwards Muskingum would be a conference title contender year in and year out. Between 1925 and 1931, Muskingum went a combined 8-0 against today's conference juggernauts Capital and Mount Union.

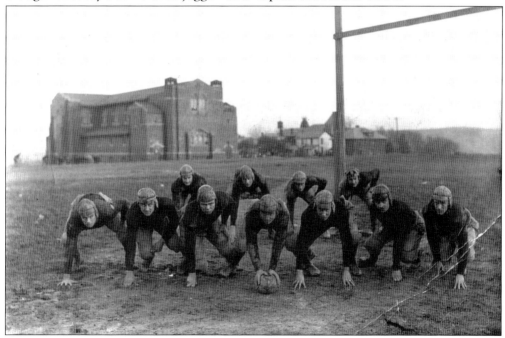

The late 1920s and early 1930s were an exciting time for the football team, the college's most followed team. Between 1926 and 1931, the Muskies won five Ohio Conference championships and had two undefeated seasons. The 1931 squad allowed just 12 points in an eight-game season.

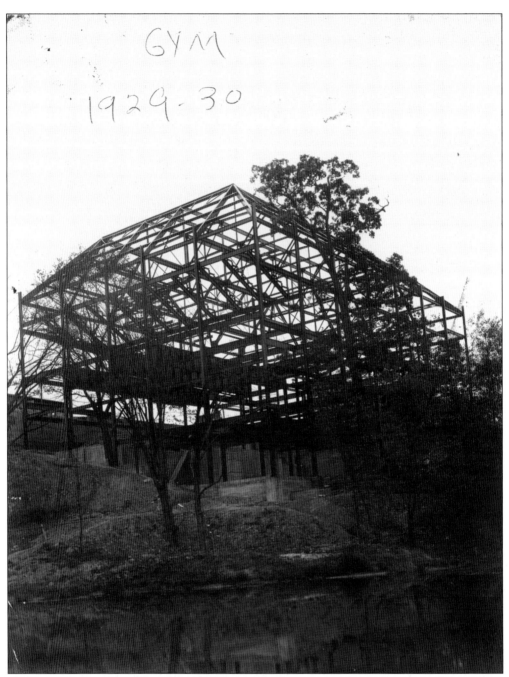

The era of growth and prosperity that Muskingum was blessed with under J. Knox Montgomery would suddenly become threatened in 1929 with the stock market crash. Freshmen enrollment dropped from 362 to 295. Construction on the gymnasium to replace the burnt barracks that had began the previous year came to a screeching halt as funds dried up. Its steel skeleton would stand unfinished as a chilling reminder of the turmoil at hand. Muskingum's fate grew even graver in December 1931, when the man most equipped to lead the college through crisis, J. Knox Montgomery, died.

Three

REALIZING A DREAM
1932–1962

The death of J. Knox Montgomery in December 1931, in the midst of a national economic crisis, threatened the very existence of the college. Montgomery could not have anticipated the greatest economic crisis in the nation's history. The college had taken on debt to complete Cambridge Hall and to begin construction of the new gymnasium, and plummeting student enrollments left Muskingum with more than half a million dollars in debt by 1932. It was in this environment that Robert N. Montgomery, one of the former president's sons, arrived at Muskingum from a college presidency at Tarkio College in Missouri. Balancing the college budget could only be achieved by extreme sacrifice. Faculty salaries by 1933 had been reduced by 60 percent since 1929 and would not return to their pre-Depression levels until after World War II. But the austerity measures worked, and the college would not face another budget deficit until 1974.

Despite the hard times, Muskingum College did more than just muddle through in the 1930s. The faculty and administration worked together in the 1930s to maintain high standards and to engage in the most productive self-examination of Muskingum's pedagogy and curriculum in the college's history. In the spring of 1934, the board supported a proposal to permit supervised dances—under the auspices of the YMCA and YWCA—by a three-to-one margin. They also agreed to permit card playing by a narrower margin. The prohibition on tobacco use remained in place.

Student social life witnessed changes in other ways as well. As Robert N. Montgomery began the process of professionalizing admissions and recruitment activities, the college expanded its recruitment efforts into the larger towns and suburbs of the region. The social clubs continued to extend their hegemony over campus social life, and by the 1950s and 1960s, small informal parties sponsored by clubs began to eclipse the elaborately planned and produced all-campus dances and events. Interest in religious groups waned in the postwar years as well, with the YMCA disappearing by 1960 and the YWCA following in the next decade.

It would take Franklin Delano Roosevelt's Civil Works Administration to finish the gymnasium in the 1930s, and the dormitory and library building projects of the 1950s and 1960s were realized through generous federal loan programs. Robert N. Montgomery's presidency was the longest in Muskingum's history, and upon his retirement in 1962, much of his father's vision of the campus had been achieved.

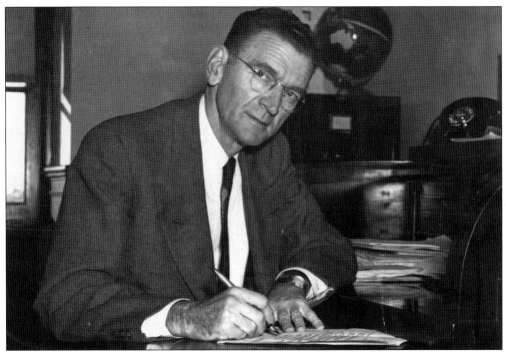

Robert N. "Dr. Bob" Montgomery, a son of J. Knox, would succeed his father as college president in the most challenging times. Work on the new gymnasium was halted and had to be finished with the help of Franklin D. Roosevelt's public works programs. It was not until after World War II that the college experienced a boom in construction and students.

One of the success stories that came about during the Depression was the completion of the gymnasium. The New Deal resulted in a Civil Works Administration grant to finish the structure, which was completed in 1935. That year would also mark the end of the worst part of the Depression at Muskingum.

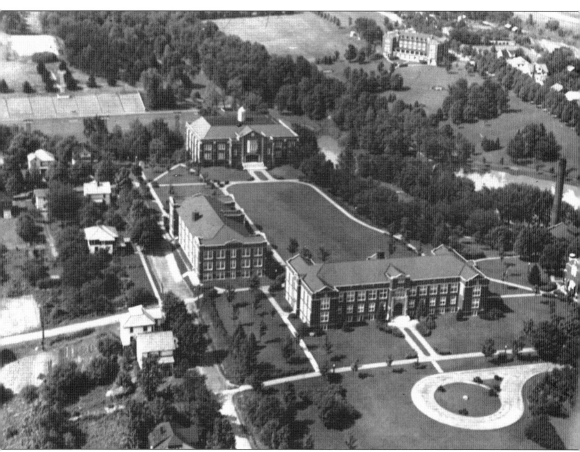

An aerial view of the campus is seen here after the completion of the gymnasium. Muskingum's recovery from the Depression was a slow one. Tuition had to be raised because of decreased enrollment despite Muskingum's strong push to attract new students. By 1938, the college nearly regained its pre-Depression enrollment, and in 1940, faculty salaries were restored to their full amount. Yet another trial was looming in the near future for the college: World War II.

With the United States' entry into World War II, college enrollment dropped again, as many Muskingum College students volunteered. On campus, support for the war effort was strong. In this picture from May 1945, Dr. Bob Montgomery auctions the shirt off his back to the highest bidder. Joanne Williams (class of 1947) won it with a bid of $1,100 in war bonds.

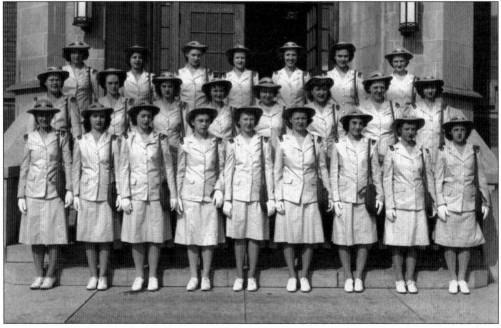

The college contributed to the war effort in other ways as well, training several classes of nurse cadets for the Women's Nursing Corps and becoming home to a unit of the U.S. Army Specialized Training Program, which brought almost 400 soldiers to campus for general education and specialized training. To accommodate this influx, the gymnasium was converted into temporary barracks.

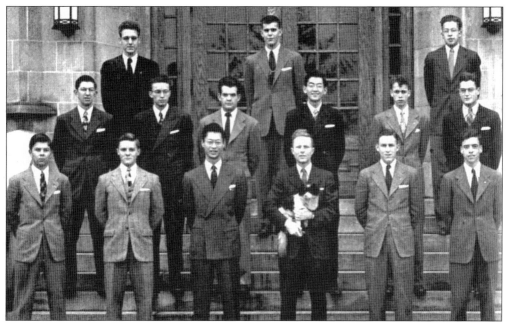

During the war, Japanese Americans living on the West Coast were interned in relocation camps. Muskingum invited eight Nisei students to come to New Concord for study, allowing them to leave the camps. Harold Shirakawa (first row, third from left) and William Oshima (second row, third from right), pictured here with the Alban club, were active in campus life. Another Nisei student, Mary Yamashita Doi, remembers her time at Muskingum as "the most important experience of my life. It allowed me to reclaim my American identity."

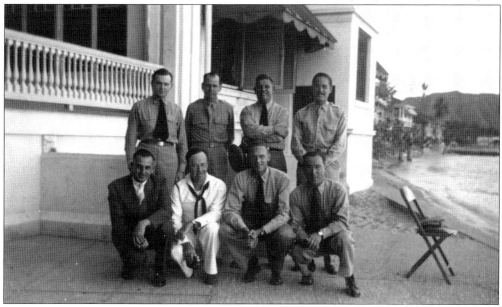

A group of Muskies that served in the Pacific poses for this picture in Honolulu on January 1, 1945. Pictured from left to right are (first row) Carl Lehman, Joe Ralston, Bill McGeary, and Jim McGaffin; (second row) Phil Caldwell, Al Kelsey, Dave Hawthorne, and Aubrey Elliott.

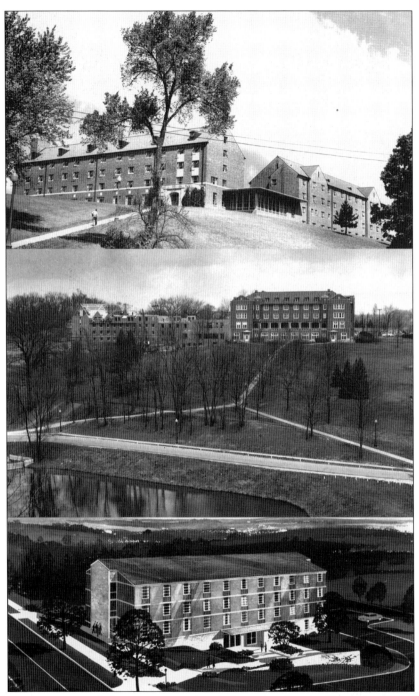

With the war over and the economy much improved, enrollment at Muskingum mushroomed. Muskingum College responded by building five new dormitories, as well as a new library and student center. The first west hill dormitory constructed in this era was the men's Memorial Hall in 1951, with the adjacent Moore Hall added later in the decade (top). In 1955, Kelley Hall was constructed adjacent to Patton on the east hill (middle). The east hill saw the addition of Finney Hall in 1961 (bottom).

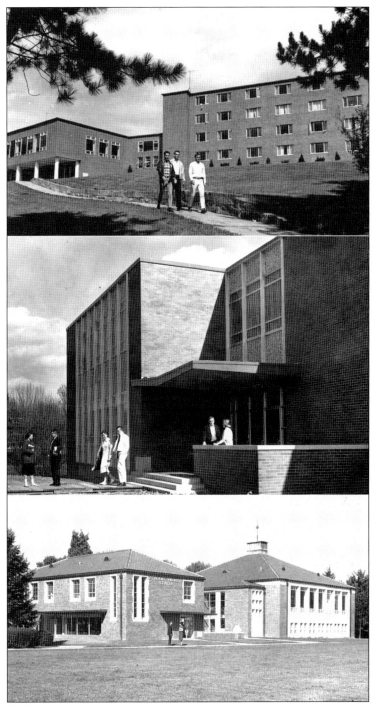

Thomas Hall on the west hill was also completed in 1961 (top). The building boom was not limited to residential facilities. In 1960, Muskingum moved the library out of Johnson Hall and into its own building (middle). That year also witnessed the construction of a student center, equipped with a snack bar and bowling alley (bottom). In total, eight buildings were constructed during the Robert N. Montgomery years.

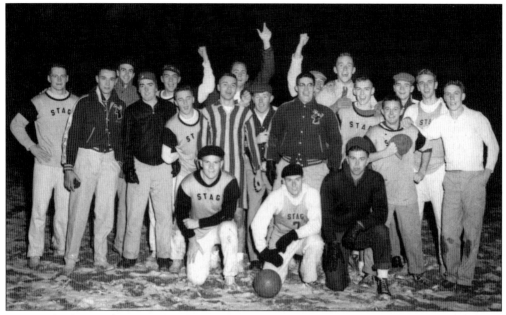

During the late 1940s, social club membership became increasingly popular and by the 1950s the clubs numbers reached their highest point. A great sense of pride in the school created a culture of students who wanted to be involved with activities on campus. The men of Stag are pictured here after a game outside.

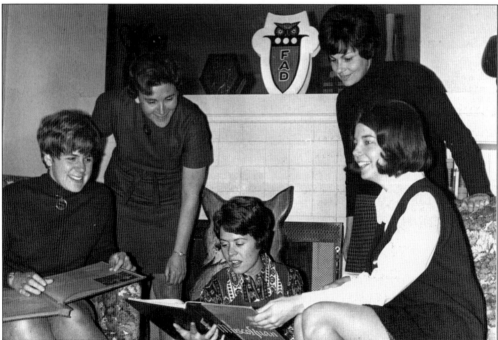

The ladies of F.A.D. are pictured here looking at the latest *Muscoljuan* in their living room. With the colors of gold and white, these ladies were known for their house and lounge parties, square dances, and won first place for the house and float decorations in 1953.

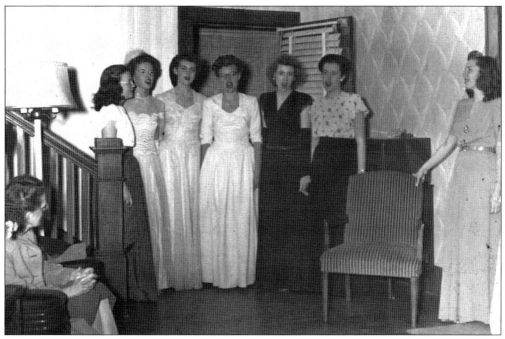

Rush week is a time where independents attend parties in order to get to know and impress clubs in order to join. In this picture, the women of Delta Gamma Theta are shown participating in a common tradition of singing to potential members into their home. The Deltas prepared an annual dinner for the football team at the end of the season, helped with the winter carnival, serenaded men's dorms and club houses, and sponsored the Blue Rock Picnic.

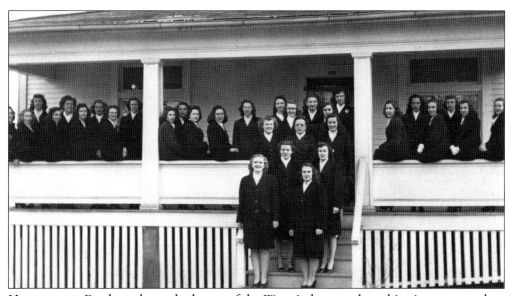

Montgomery Boulevard was the home of the Wawyin house when this picture was taken in 1947. They were known for their cookouts in the hollow, lounge parties, square dances, and annual formal parties. Their colors were purple and orchid.

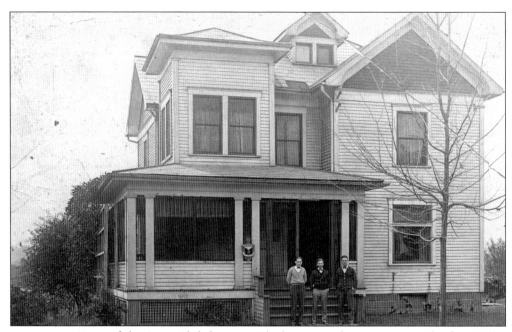

Here is a picture of the Stoic Club house with three members posing in the front. The Stoic Club focused more on their brotherhood than the traditions of ritual and secrets central to other clubs on campus.

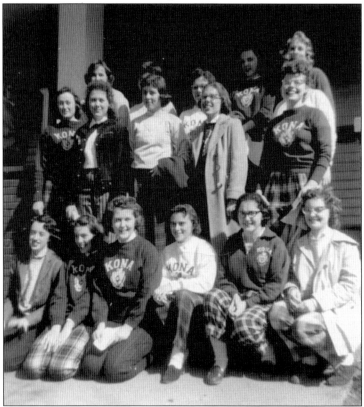

The increased interest in clubs created new groups such as the Kona Club, formed in 1942. Their colors were brown and yellow. They were known for their annual hayride, Christmas parties, lounge parties, and a formal.

Philathea was formed in the 1940s and described itself as an organization with the goal of providing "group social life for those girls who do not choose to go club." When in 1947 another women's club called Athala was formed, followed by the men's Ulster club in 1948, the college tried to impose a quota system to ensure membership was equally distributed in a crowded field. This experiment was short-lived, and clubs continued to come and go.

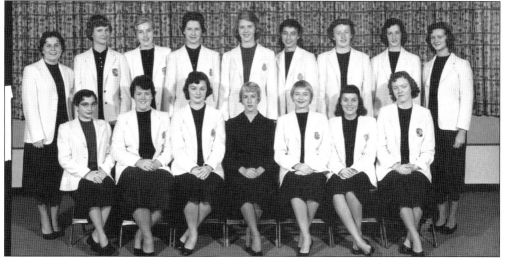

Athala lasted just 10 short years before it dissolved. In 1958, 18 freshman women formed a new club they named Beta Kappa Chi. On pledge day, they met together at a restaurant in Cambridge where they created their colors, creed, and beliefs. Pictured here are the women in 1959, a year after the founding of this group.

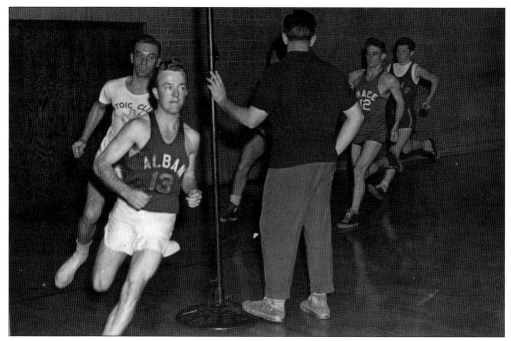

Intramurals were a fun way for social clubs to compete against each other and to create pride within the members of each group. Each club participated in sports such as basketball and football. Here a representative of the Alban club leads the pack, followed by a Stoic member. The Mace and Stags trail behind.

Homecoming was another opportunity for members of the social clubs to show their pride. This was a much anticipated event for social clubs on campus. To welcome the alums and show their Muskie spirit, each club would decorate its house in elaborate ways. The Alban clubhouse is shown here with its decorations. Competitions for the best house and float decorations encouraged the clubs to put lots of time and effort into homecoming preparation.

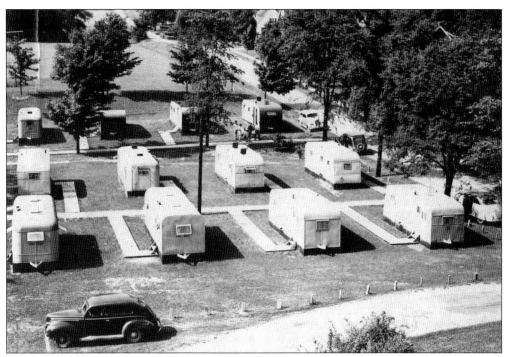

One interesting facet of the postwar era under Dr. Bob Montgomery, was the Trailwood Heights Community. Trailwood Heights residents were married students, many receiving their educations as a result of the G.I. Bill. They resided in 16 trailers that were purchased from the government when the college was in need of housing for students before the dormitories were completed. These residences were located on what is today the Kelley upper parking lot.

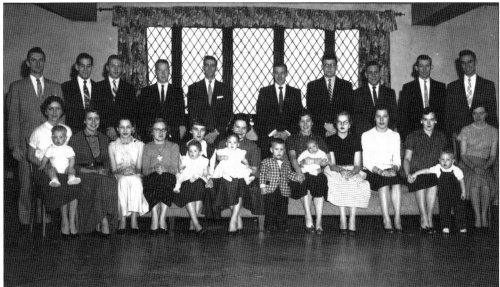

Trailwood Heights residents existed as an autonomous community within the college. Many of the couples had children. They elected their own mayor and planned their own social events. In this 1956 photograph, the man second from the left is Mayor Bill Flagmeier.

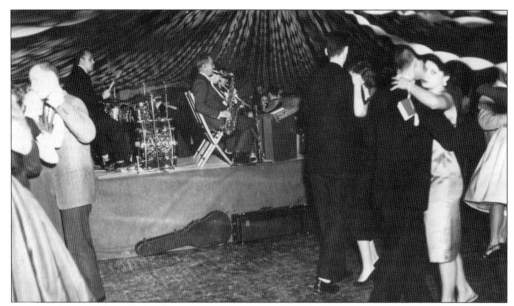

The Muskingum students during the 1950s were heavily focused on becoming involved and creating activities on campus and being part of the campus as a collective body. Dances were among these important activities that involved the entire student body. Different groups would put on dances with live bands and extensive decorations. This particular dance took place on March 10, 1959.

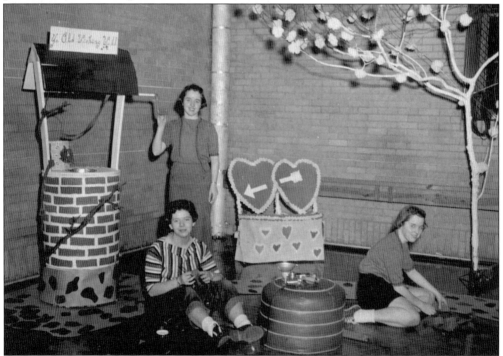

In 1957, the freshman hosted a dance on February 15. The theme of the dance was "Hearts and Flowers," and featured an outdoor spring theme with hearts. The music of Shelly Carlisle was featured. Pegi Marshall was crowned as freshman class queen.

Dances were often attended by formal wear of a suit and tie by the men and fancy dresses with white gloves by the women. Another great dance that was the highlight of this time was called "Sejuna." The junior class sponsored this dance for the seniors. In 1957, the theme was "Zanzibar"; a dance that transformed the gym into a desert island. Themed dances featured elaborate decorations.

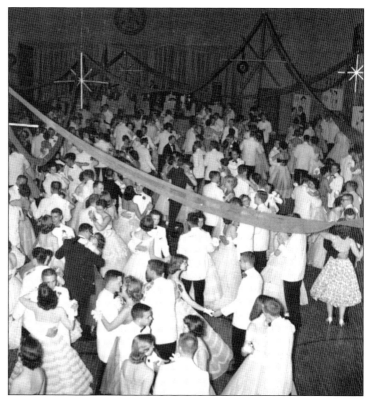

This "Soph Hop" took place in 1957. It featured an "underwater fantasy" with "sea foam" and starfish-shaped cookies served as refreshments. Paul Campbell's Orchestra played, thanks to cochairs Anne Moore and Jim Black, for this event.

Social life on campus changed with the passing of seasons. Hayrides were popular as were cookouts. These ladies enjoy a meal in the hollow. The picture appeared in the 1957 *Muscoljuan*.

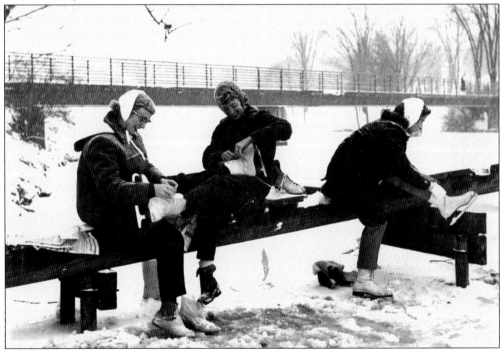

When the autumn leaves were all on the ground and snow flakes began to fall, life outdoors shifted to the lake where students would ice skate. These ladies were featured in the 1960 *Muscoljuan*.

In spring, students grew restless as the academic year came to a close. Each May, seniors held a student walkout day, without their professors' knowledge, and students gathered to play baseball and enjoy the festivities. Here the members of the class of 1959 enjoy the final weeks of their Muskingum career.

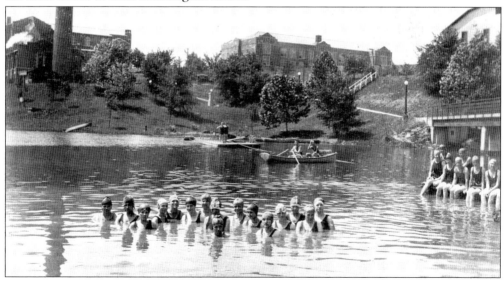

When summertime came, the lake once again became the center of excitement. Swimming and boating continued to be the preferred retreat on hot summer days.

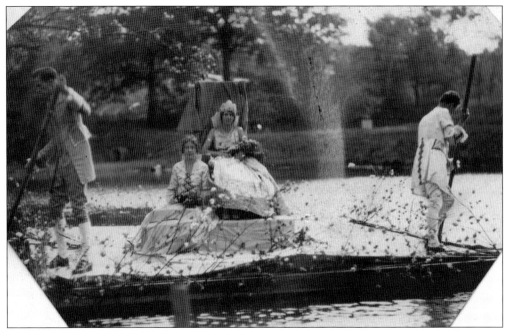

May Day continued to be a part of spring gaiety on the campus. In some years, the May Day Queen arrived at her throne in the hollow by way of boat. Here the queen of 1932 floats gracefully as she prepares to ascend to her court and preside over the day's festivities.

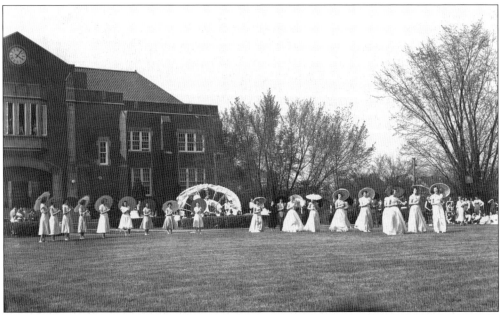

Eventually May Day activities were relocated to the quadrangle. Despite this innovation, the traditions of elaborate costumes and the maypole dance remained.

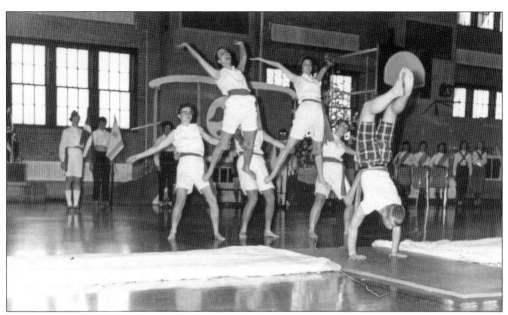

May Day continued to be organized as part of the women's physical education program. These young ladies perform a gymnastic routine as part of the year's program of song and dance. May Day was occasionally held indoors due to rainy weather.

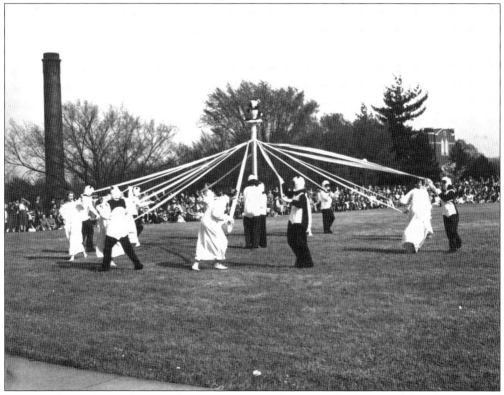

Here students dressed as pandas participate in the maypole dance, while a large crowd looks on.

During dink week, freshmen were required to wear a beanie with their graduation year sewn on and a large name tag. Throughout the week, freshmen were told to perform various activities in order to better associate themselves with the people, traditions, and history of the college. One assignment was to have 85 signatures of upperclassmen on the back of their name tag.

One important task performed during dink week was the polishing of the seal in Montgomery Hall. Most of the activities were meant to be a lighthearted way of getting to know the college and other students of the college.

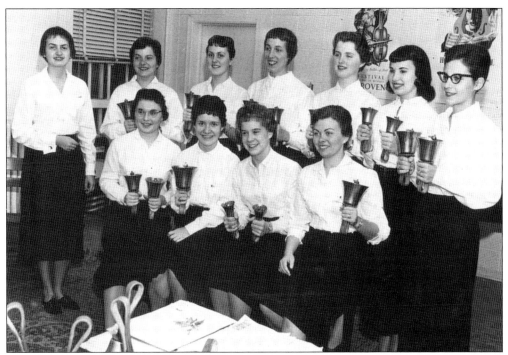

When the bell choir was founded in 1957, it made Muskingum College the only institution of higher learning in the Midwest with a bell choir. The bells were donated by the Brick Presbyterian Church of New York City in honor of Robert N. Montgomery's sister Geneva for all of her hard work for that church.

Sigma Alpha Iota is an international music fraternity that began the Alpha Gamma chapter at Muskingum in 1927. On campus, they are known for their musicales each semester, helping with other performances, and putting together various social activities.

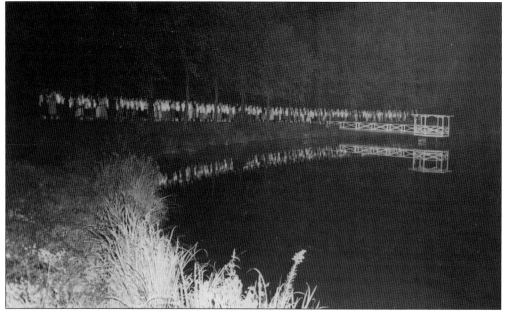

Here is a large gathering of the members of the YWCA along the lake. The YMCA and YWCA endured longer at Muskingum than many other colleges because of the interest and involvement of Dr. Bob Montgomery, who saw the Christian education of the students as his chief responsibility as president.

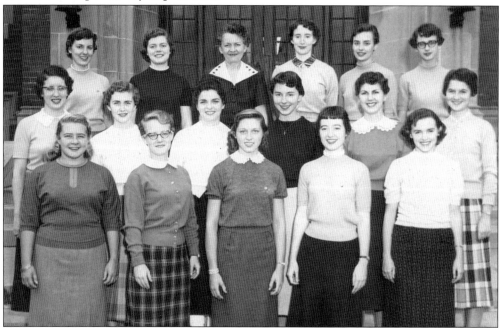

Pictured here is the YWCA group from the 1957 *Muscoljuan*. From left to right are (first row) B. Topping, D. Regan, K. Wyer, J. Smith, and J. Wagstaff; (second row) B. Davies, B. Curran, S. Mugnani, M. Morse, N. Mitchell, and P. Harman; (third row) M. Montgomery, S. Johnston, Gertrude Barr, B. Averill, P. Lietch, and B. Sittig. This group sponsored activities such as the World University Service Drive and Spiritual Emphasis Week.

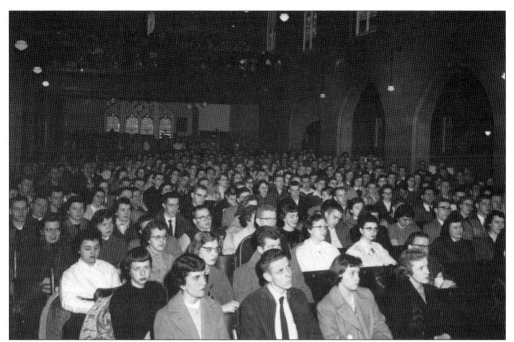

Chapel services were still required every week under Robert N. Montgomery. Various professors and visiting lecturers were featured at these services. Each student had an assigned seat, and attendance was taken. Note that the back of the chapel originally had a large stained-glass window where what is now the main entrance to the chapel is located.

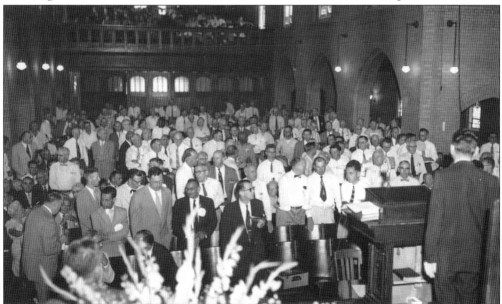

A monumental event in the history of the United Presbyterian Church took place at Muskingum College. In 1958, at their 99th annual meeting, held in Brown Chapel, representatives of the presbyteries voted to merge with the Presbyterian Church U.S.A. College president Robert N. Montgomery served as the moderator, an important position his father held years before.

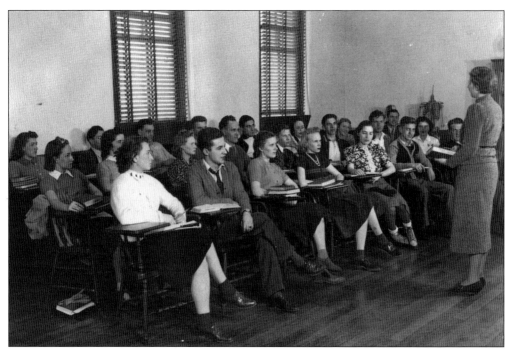

During Robert N. Montgomery's tenure and as a part on the college's centennial celebration, the college issued an important study concerning the methodology of teaching. Titled "A College Looks at Its Program," faculty members submitted studies on student's performance based on the format in which their lessons were taught. One aspect of the report was a study by the president on what moral standards should be placed upon the students.

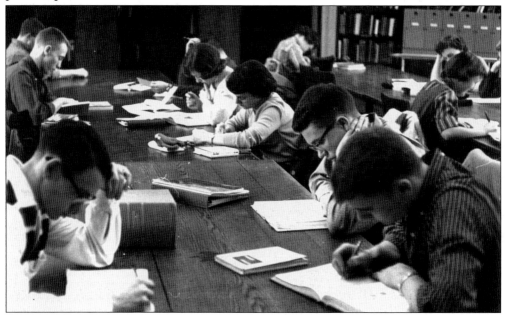

Before the creation of the library in 1960, students studied in a cramped library in Johnson Hall.

Home economics was a major at Muskingum during this era. Students learned how to cook in the kitchen in the basement of Brown Chapel. The number of majors dramatically increased during the Robert N. Montgomery years as the college responded to changing student interests.

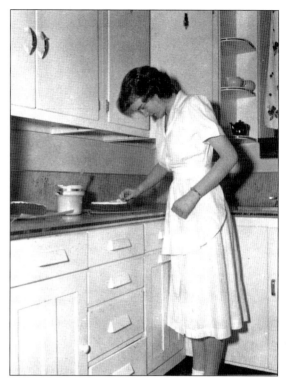

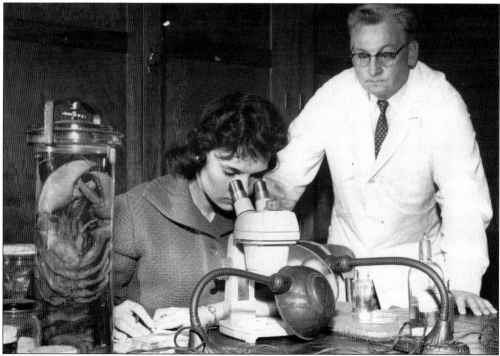

Student Diana DeBlander peers through the microscope as her professor, Dr. William Adams, looks on. Before the creation of the Boyd Science Center, science courses took place in Cambridge Hall.

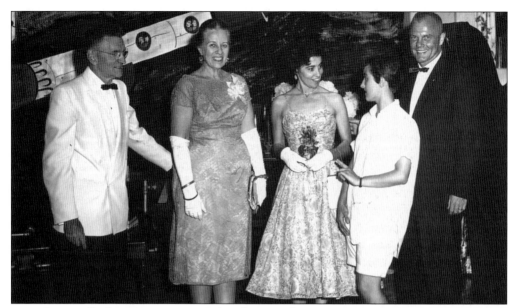

New Concord's favorite son, Lt. Col. John H. Glenn Jr. was a student at Muskingum before World War II. He is seen here at a student reception in 1959 with his wife, Annie Castor Glenn, Robert N. Montgomery and Ruth Montgomery, and student Suzie Wilson. Glenn's career in the U.S. Air Force led to him becoming an astronaut on the Friendship 7 mission. On March 3, 1962, an estimated 40,000 people flocked to the Muskingum campus to welcome him home.

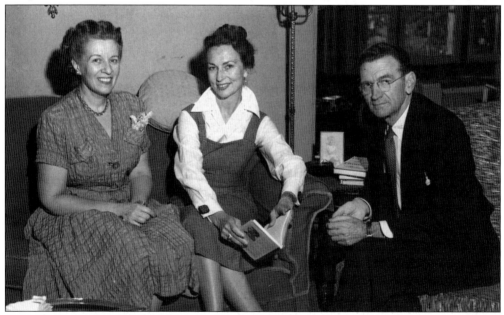

Agnes Moorhead, seen here with the Montgomerys, was a member of the class of 1923. During her years at Muskingum, she was a member of the Delta Club and active in drama and athletics. She started her acting career in radio and Broadway, her first role on screen was in 1941 in *Citizen Kane*; following this was her award-winning performance in *The Magnificent Ambersons*.

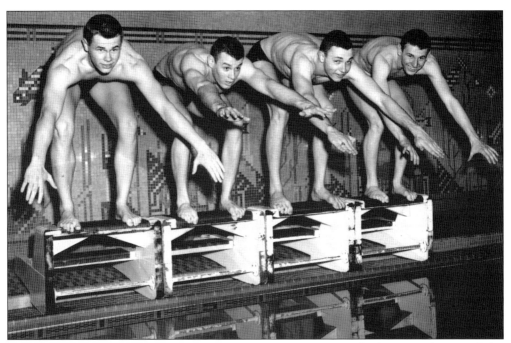

Swimming came to Muskingum as a competitive sport with the completion of the gymnasium, which was equipped with a pool that was state-of-the-art in its day. Surrounded by a tile seascape, the 20-yard pool still sees much use today.

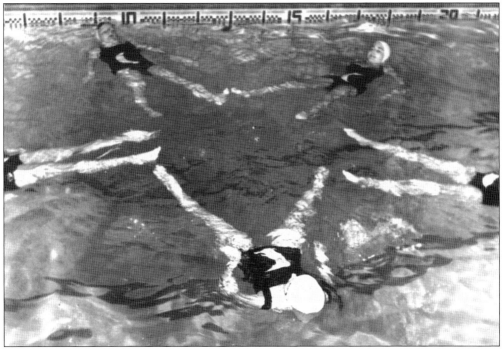

While men participated in racing, women formed a synchronized swim team. The Aqualinas dazzled spectators with their agility and grace. These ladies were members of the 1959 Aqualinas team.

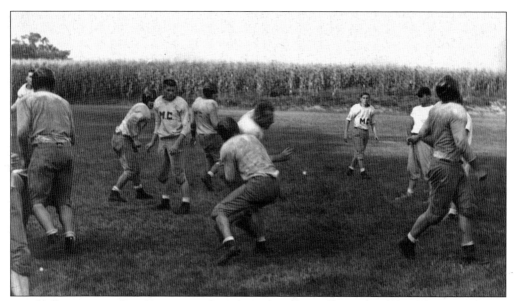

Football continued to be a proud tradition at the college on the hill. The era was characterized by consistently strong teams. During the war years, scheduling opponents became difficult and the season was shortened. In 1943, the season consisted of just two games, both against Rio Grande. Irregular opponents included Patterson Air Force Base and Fletcher Hospital. The cadets stationed on campus also organized a team of their own. Here a Muskingum team practices in a cornfield.

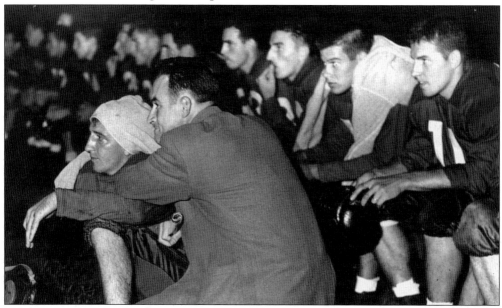

The man responsible for Muskingum's on-field success was coach Edgar Sherman, whose coaching record stands at an unmatched 141-43-7. Sherman led the Muskies from 1945 to 1966. Muskingum won the Ohio Conference in 1939, 1949, 1950, 1955, and 1960. In the 1955 and 1960 seasons, the Fighting Muskies went undefeated. From 1957 to 1960, Bill "Cannonball" Cooper set college records in points per game, per season, as well as by career. He also set season and career records for touchdowns.

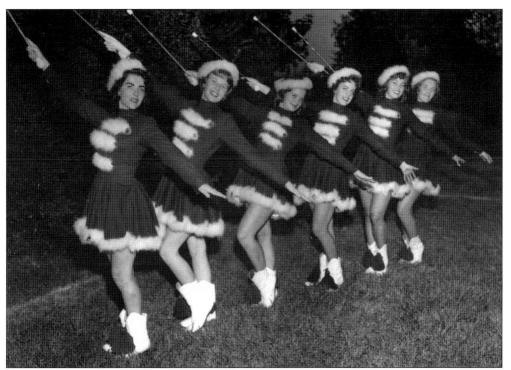

The majorettes were an important part of the Saturday gridiron matchups. Here the line poses for its 1959 yearbook picture. Pictured from left to right are Roselia Hoy, Janie Furbay, Karen Horten, Betty Butler, Estelle Murray, and Betsy Hill.

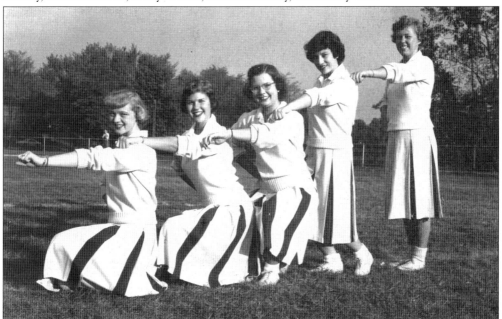

Victory could not be won with out the help of the loyal Muskingum cheerleaders. These young ladies, from left to right, Anne Ringer, Carol Rehman, Janet Brown, Char Brokar, and Barb Johnston, supported the 1952 team.

Dr. Bob Montgomery's service to the college augmented beautifully the legacy begun by his father. J. Knox Montgomery's dream of a grand Muskingum was realized by his son. In 1962, Montgomery stepped down from the presidency, bringing an end to his 30-year term. He assumed the office of chancellor, a position created for him, and was appointed to the task of fund-raising.

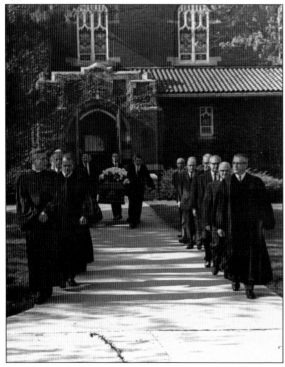

In 1965, Montgomery resigned the chancellorship; his Parkinson's disease had begun to diminish his capacity to serve. In 1967, Muskingum said goodbye to one of its most beloved presidents.

Four

A COLLEGE IN TRANSITION 1962–1978

Through depression, war, and into the postwar boom, Muskingum College had moved forward under Robert N. Montgomery's leadership. The next 16 years would see four different men assume the presidency. The 1960s witnessed a steady increase in college enrollments as the baby boomers came of age. Enrollment reached its peak in 1969, when 475 freshmen entered Muskingum College. From that point forward, the decline was precipitous. A total of 413 freshmen arrived in 1970, and just 368 in the following year. Enrollment continued to decline, and by 1979, enrollment had dropped more than 35 percent across the decade to just 850 students. The reasons for this decline were primarily external—declining numbers of high school graduates, the end of the draft, increasing competition from public university branches and community colleges, and a souring economy. In 1974, the college confronted its first budget deficit since 1932, and there were few signs of hope for a quick turnaround. Muskingum College had endured lean times before and proved capable of doing so again.

One bright spot in these lean years was the opening of the new state-of-the-art science center in 1970, made possible by a federal grant targeting Appalachian communities. After its completion, no major building projects would be undertaken for more than a decade.

Like the 1920s, the 1960s proved to be another decade of transformation in youth culture, but unlike the earlier decade, this generational revolt incorporated elements of political activism as well as rebellion against social codes. The impact of the decade's youth revolt on Muskingum College students was similar to the 1920s as well. In many ways, the major symbols of youth protest caused only ripples on Muskingum's campus. Civil rights and antiwar protests engaged only a small minority of the Muskingum student body. In response to student objections, the college liberalized its policies on dress and behavior, ending the prohibition of long hair in physical education classes, instituting more permissive visitation rules in the dormitories, and tolerating student alcohol consumption on campus.

There was a significant expansion of women's intercollegiate sports during the era, and soccer arrived as a men's sport. The social clubs continued to play a significant role in campus social life, but some clubs disappeared, and even among those with healthy numbers, it was not uncommon for juniors and seniors to disaffiliate from the clubs they had eagerly pledged as freshman.

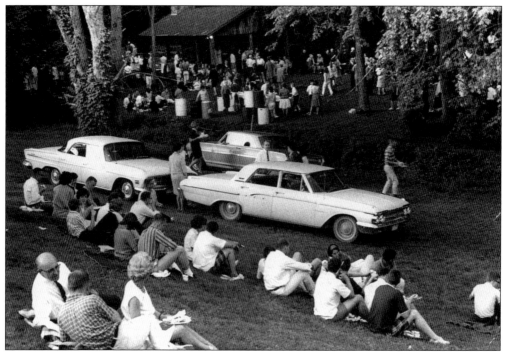

During the time after the Montgomerys' presidencies, much of the traditions and simplicities of Muskingum had prevailed. Former vice president Glenn L. McConagha became Muskingum's new president, the first president in 58 years to not bear the name Montgomery. Here student and faculty enjoy a picnic in the hollow in 1965.

A group of young women make a memorable late-night visit to the Ulster house by dressing up as Native Americans. In many ways, the early part of the decade was a continuation of the values and norms of the 1950s.

The football program, with Edgar Sherman at the helm, continued to perform well on into the 1960s. The Fighting Muskies won the Ohio Conference in 1965 and 1966. The team also received invitations to play in the Grantland Rice Bowl in 1964 and 1965. Here fans endure the falling snow in order to show support for the Black and Magenta.

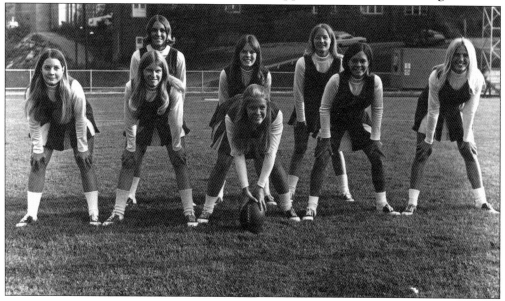

Here the 1970 cheerleading squad poses. Muskingum's team would continue to perform well into the 1970s and won another conference championship in the renamed Ohio Athletic Conference in 1975.

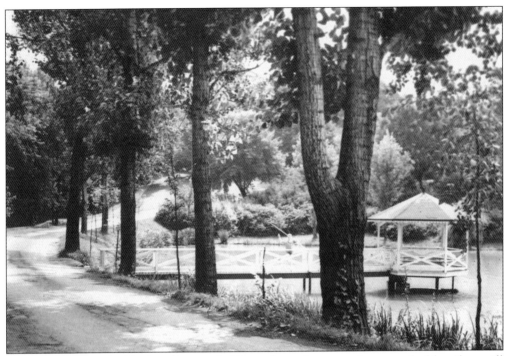

Campus tradition holds that if a couple kisses three times on the spoonholder, they will marry. The lake's use as a swimming hole came to an end as the development of septic tank suburbs upstream began to affect water quality. The lake increasingly came to be seen as a place for nature contemplation. Large trees shaded the east side, and cattails and other plant life were allowed to grow along its banks, providing a more naturalistic look.

The north end of the lake became home to Muskingum's swans. Here a couple attempts to coax the swans closer with food. Stories abound of unsuspecting students being chased by the graceful yet sometimes aggressive waterfowl.

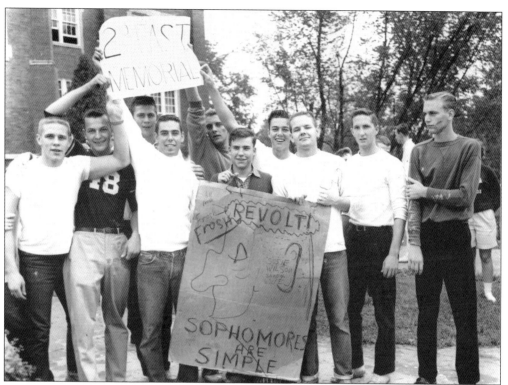

The old traditions of freshman-sophomore rivalry persisted in some form long after the scrap day competitions were ended. Here a group of freshman assert their rights and make it known that they will not be pushed around by sophomores.

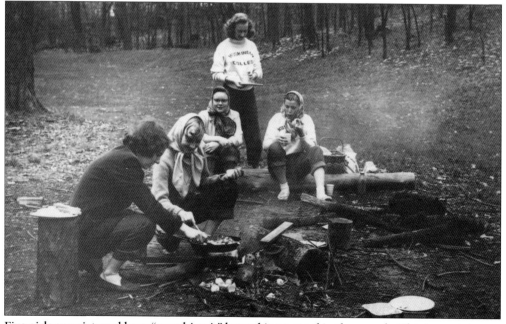

Five girls are pictured here "roughing it" by making a meal in the woods. This is reminiscent of the days when women's athletics consisted of groups such as the hiking club.

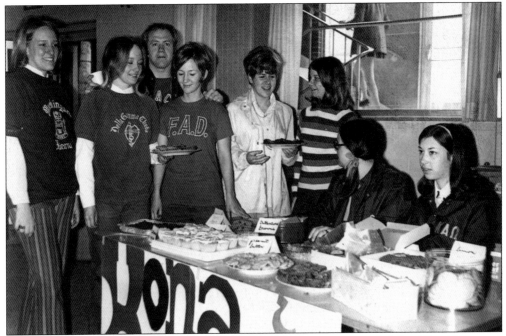

The 1950s had been the high-water mark for the on-campus social clubs. The 1960s and 1970s marked a gradual decline in these organizations. Here members from the Kianu, Delta, Mace, and F.A.D clubs enjoy a Kona Club bake sale.

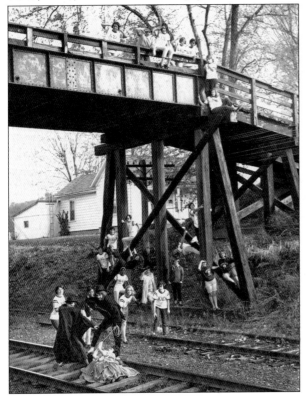

The first of the women's clubs to fall was Athala in 1958. Wawyin, the third-oldest women's club, succumbed to a declined membership and financial trouble in 1965. The Konas, pictured here in 1968 at the Liberty Street railroad bridge, disbanded in 1973. The Stoic men's club also folded in 1964.

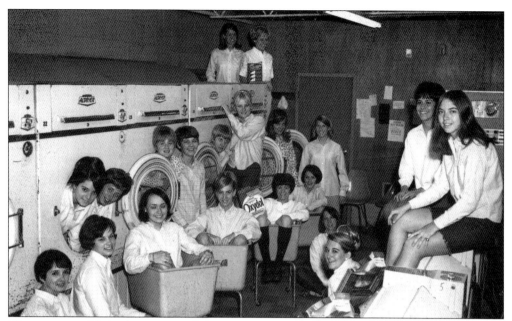

The more established women's clubs were joined by a new club, Phi Kappa Pi soon after the capitulation of the Wawyins. Here the ladies pose for the 1968 *Muscoljuan* in the laundry room. This club would eventually be colonized by the national women's sorority Sigma Sigma Sigma in 1984 only to cease to exist after 1985.

Dramatic change would also come to the men's clubs. The Sphinx Club, founded in 1910, became part of a national organization, Kappa Sigma, in 1966. Here members are involved in a greased pig competition.

The Alban club also became part of a national fraternity, Phi Kappa Tau, in 1968. Here members volunteer as New Concord firefighters in 1972.

The social clubs made contributions to the campus as well as the community. Here members of the Ulster club paint the Sonora United Methodist Church.

Greek Day also became a tradition between each social club. It featured contests between the clubs. Here members of the women's clubs participate in a bike race. Other competitions included egg toss, tug of war, and an eating contest.

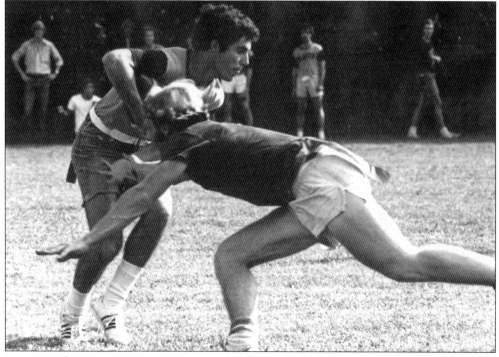
Intramural sports were a popular outlet for club rivalries to take place. In this flag football picture from the 1971–1972 academic year the Stag player dives for the Ulster player's flag.

Following Glenn L. McConagha's brief presidency from 1962 to 1964, Harry S. Manley would be the next to occupy the office, holding it from 1965 to 1970. Manley was able to make some academic improvements to the college, reorganizing the academic calendar and making classes worth an equal number of credits. Here Manley speaks at the naming ceremony of Finney Hall.

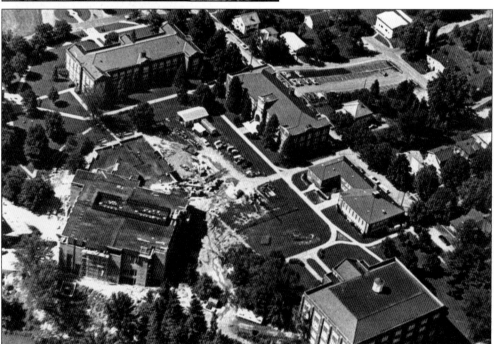

Manley's greatest achievement at Muskingum was the appropriation of funds through a federal program to develop the Appalachian region in order to construct the science center, which at its time was cutting edge. Construction, as seen in this aerial view, began in 1969. This picture was taken in August 1970.

Manley's successor was William P. Miller. Miller took the helm in trying times, as student enrollments peaked and then began a precipitous decline. Miller would be president from 1970 to 1975.

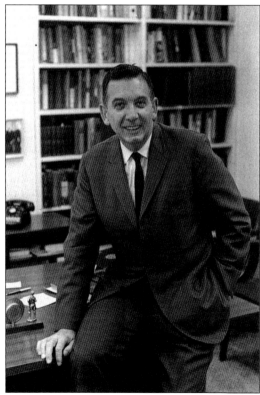

John A. Brown would be the fourth of four presidents during a 16-year span. Brown's administration began in 1975. He served until his death in 1978.

As the decade moved on, students began to act with greater autonomy and started to question the need for the long-standing traditions that Muskingum had held so dear during the Montgomery era. The tradition of avoiding stepping on the seal in Montgomery Hall for fear of bad luck was challenged in this photograph that appeared in the *Muscoljuan* in 1975.

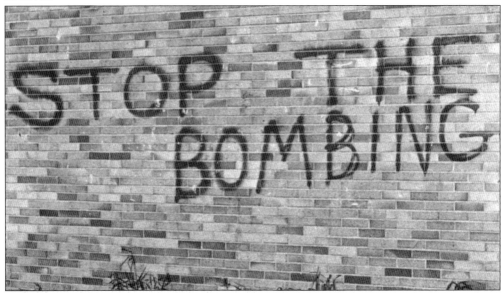

During the 1971–1972 academic year, students vandalized Boyd Science Center in protest of the Vietnam War. Just as the college had been unable to insulate itself from the generational revolt of the 1920s, the second wave of youth rebellion in the 1960s and 1970s subtly reshaped student life on campus.

The Kianu Club parades down Comin Street alongside a Volkswagen van. The spirit of the 1960s affected Muskingum College students in cosmetic ways, such as dress and hairstyle, but was not manifested in widespread political agitation.

Students became increasingly freer in the ways in which they expressed themselves such as this student seen here in his Thomas Hall dormitory. It was a time in which *groovy* was in and *square* was out.

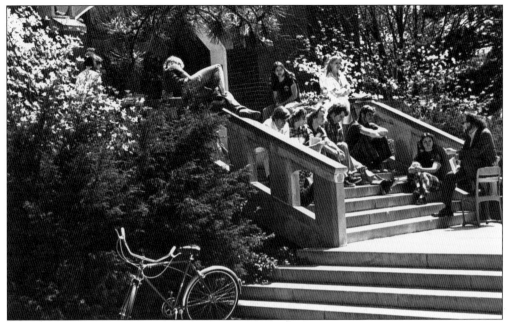

The more recent additions to the faculty were more diverse in their outlooks, perspectives, and even appearance, from earlier generations of faculty. But the core goal of the faculty, embodied in a mission statement that sought to "develop intellectually, spiritually, social and physically whole persons" was not so far from the ideals of J. Knox Montgomery, who had told earlier generation of Muskingum College students, "What you are to be, you are now becoming." A lecture is given on the recently constructed entrance to Brown Chapel. The entrance was created in 1964 as part of a renovation project.

The emphasis on inculcating social responsibility in students and a commitment to making a difference took new forms as new concerns came to the forefront. Here students launch a recycling campaign on campus. Green initiatives continue to engage significant numbers of Muskingum students.

The skateboarding craze of the late 1970s also came to campus. Here a student "hangs ten" on a barefoot ride down the Mem-Moore sidewalk.

Students are pictured here on the quad roller-skating in front of the student center. The *Muscoljuan* yearbook took on a new look in this era as well, eliminating most text in favor of uncaptioned images that captured the spirit of the times but recorded few names, dates, and facts.

The 1968–1969 Finney Hall second-floor south girls were a tight-knit group, as is evident by the scrapbook they left behind detailing their time together as a floor. This is but one of the many candid shots that they took. Students would have listened to the popular music of the era.

Two students sit outside Johnson Hall, home of the art department, while they sketch. Involvement in the arts became more common among the students with changes in class structure that allowed for greater flexibility for elective courses.

Prof. James Anderson is seen here creating the sculpture titled *Ursbleim XIV* that is currently displayed on the quad near Boyd Science Center. This sculpture was created between the years of 1971 and 1972.

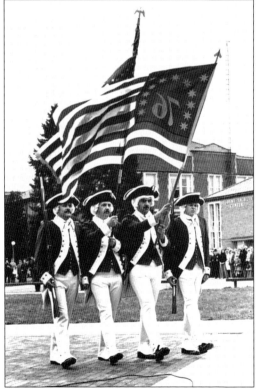

Caught up in the spirit of '76, the bicentennial of the United States was celebrated with pomp and circumstance at Muskingum. Townspeople dressed in period clothing leading a procession across the quad are pictured here. Even the John Glenn High School band became part of the spectacle, dressing in Colonial garb as it paraded across campus.

The era produced yet another significant alumnus, Jack Hanna. As a student, he brought a donkey named Doc that found a home behind the MACE house. Doc became the mascot for Muskingum and helped Hanna find his future wife, Suzi Egli, a cheerleader that he met in French class.

Hanna became the director of the Columbus Zoo and hosted television shows about the animal kingdom. In 1980, Hanna returned to his alma mater as the convocation speaker. Accompanying him was Emily the chimp, seen here in the college bookstore with Mary Anne McCormick.

Five

PATHWAYS TO THE PRESENT
1978–2009

Muskingum College began its recovery from the uncertain times of the 1970s when leadership of the college was handed to the new president, Arthur De Jong, in 1978. The board gave De Jong the difficult but critical task of balancing the budget by reducing operating costs to keep them in line with the smaller student enrollments. This required reducing the size of the faculty and the release of a number of tenured faculty from employment. This painful process did achieve the needed result. The college was able to balance its budget, and has maintained balanced budgets ever since. The college was also able to halt the decline in enrollment, but the size of the student body remained below 1,000 when De Jong retired in 1987.

The board selected Samuel Speck, professor of political science, state legislator, and former associate director of Federal Emergency Management Agency (FEMA) to succeed De Jong. Dr. Speck revitalized fund-raising and embraced a bold plan to address the enrollment issue, by launching a tuition repricing plan in 1996 that slashed tuition by $4,000. Muskingum College shot to the top of many lists for the best value in education, and the numbers of students applying for admission to Muskingum increased dramatically. In 1997, undergraduate enrollment exceeded the previous peak year of 1969 and continued to climb.

In January 2000, Anne Steele assumed the presidency. She has led a period of significant growth in terms of undergraduate and graduate enrollment, faculty resources, and investment in facilities. New undergraduate programs in criminal justice, digital media design, engineering science, and nursing were developed, and a masters of arts in teaching and the masters in information strategies, systems and technologies added at the graduate level. By 2008, the college had successfully completed a $70 million comprehensive fund-raising campaign.

Student life has also seen changes in recent decades. The college witnessed the increasing professionalization of the student life office in these years, and there has been a steady diversification of the student body. While Greek organizations remain important centers of campus social life, there has been a heightened social consciousness among students, and involvement in issue-oriented clubs has grown steadily. The long traditions of service and idealism, once embodied in the YMCA/YWCA and Christian mission groups, now find outlets in annual events like the Relay for Life and in groups addressing current-day concerns, from environmentalism to poverty to the rights of gay and lesbian students.

Arthur De Jong served as president from 1978 until 1987 and steered the college through some of its most difficult years. De Jong is seen here with Egyptian president Anwar Sadat on a visit to Egypt on March 15, 1980. The college awarded President Sadat with an honorary degree, in recognition of his critical role in bringing peace between Egypt and Israel.

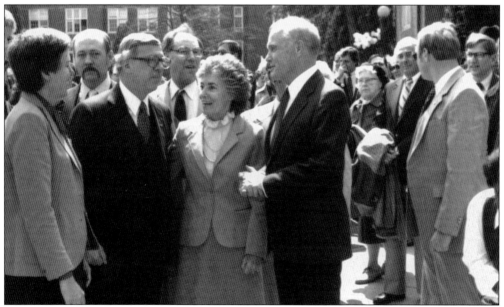

New Concord's favorite son, John H. Glenn Jr., began a long political career as U.S. senator for the state of Ohio starting in 1974. Senator Glenn announced his candidacy for the Democratic nomination for the 1984 presidential election here at Muskingum College on April 21, 1983, once again drawing a large crowd and news crews to Muskingum. Glenn would remain on Capitol Hill until 1998.

The campus would once again see change in 1985, when the new recreation center, adjacent to the gymnasium, was opened. The recreation center was the first new building to be added in 14 years. The additional space and modern facilities were much needed by the athletic department.

Another dramatic change to the landscape of Muskingum College that year was the draining of the college lake. As part of the project, work was done on the bridge across the lake and a new spoonholder was built to replace its aging predecessor. The draining of the lake put to rest—but only for a few years—the long-lived campus legend that John Glenn's car rested at the bottom of the lake.

On March 10, 1986, the campus was rearranged in a different manner when a tornado swept through, destroying numerous trees, some rather large, as well as stripping some of the signature red clay tiles from the roofs of the campus buildings.

On Sunday evenings, the dining hall was closed to students. To compensate for this, many students would go to the fraternity houses for cookouts. Pictured here are some students enjoying a meal at the Kappa Sigma house. During one Kappa Sigma ox roast in the 1980s, the ox fell off the spit, landed in the fire, and sent flames 30 feet into the air. (Courtesy of Mark Miller.)

During the 1980s, air band competitions were common. Groups would pretend to be a band and lip-sync to the song of their choice. Pictured here is the Kianu air band in the 1981 Centerboard Airband competition. Centerboard was established as a student organization responsible for organizing entertainment on campus. (Courtesy of Chi Alpha Nu.)

In 1987, the Beta Delta chapter of Theta Phi Alpha was founded, making them the second group to try to create a chapter of a national sorority. The women of Theta Phi Alpha have brought a new tradition of the American Red Cross blood drive to Muskingum. Pictured here are the founding members during their pledging on September 19, 1987. (Courtesy of Theta Phi Alpha.)

Samuel W. Speck, class of 1959, became president of Muskingum College in 1987, after serving the college for more than two decades as a professor of political science. Speck's tuition repricing plan was heralded in *U.S. News and World Report* as "a move virtually unprecedented in academia." The bold plan worked and launched Muskingum College into a new era of prosperity and growth. Here Dr. Speck is pictured with his wife Sharon, class of 1960.

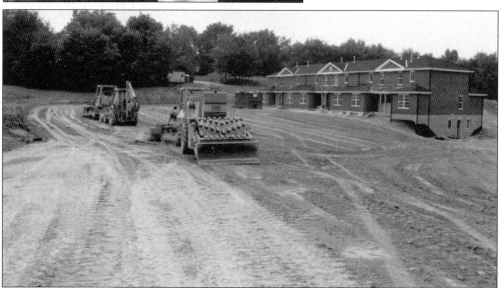

Among Dr. Speck's many other accomplishments as president were the installment of a state-of-the-art telecommunications system, the renovation of historic Patton Hall in 1996, and the construction of the townhouses (seen here) in 1998, which helped to accommodate the now-growing student body.

The 1990s brought with it the establishment of academic honoraries Lambda Sigma for sophomores and Omega Delta Kappa for juniors and seniors. These organizations served to fill the void left during the 1970s when local honoraries O.O.O.O., the Cwens, and others ceased to operate. These honoraries continue to strive for academic excellence and contribute to the campus and community through their leadership and philanthropic endeavors.

On October 29, 1998, Muskingum alumnus John H. Glenn Jr. once again made history when he began a nine-day mission aboard space shuttle Atlantis, mission STS-95, becoming the oldest person to enter space, 36 years after becoming the first American to orbit the earth. Glenn's return to space ignited much excitement at the college. Students assembled in the recreation center to watch the historic launch.

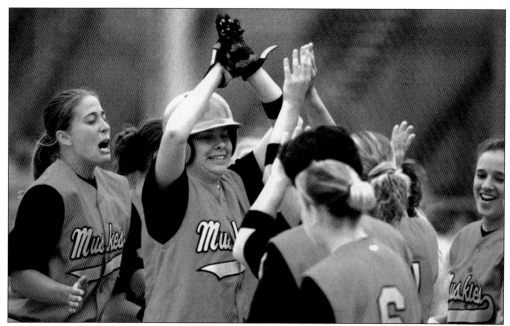

Muskingum's softball team, under coach Donna Newberry, has produced a dynasty that cannot be rivaled. The team captured 18 Ohio Athletic Conference titles over a 22-year period from 1986 to 2008; made NCAA Division III tournament appearances in 1988, 1989, 1990, 1991, 1993, and 1995; were regional runner-ups in 1999, 2000, and 2002; were regional champions in 1992, 1998, 2003, 2004, 2005, 2006, and 2008; and in 2001 made history defeating the Central (Iowa) Dutch in the NCAA Division III World Series, capturing the college's first-ever national title.

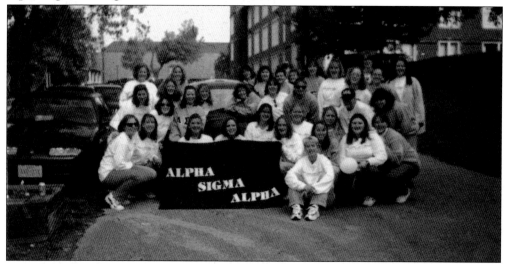

Social clubs on campus rebounded during the era, with three new organizations forming in a decade's time. Alpha Sigma Alpha became the third national sorority to appear on campus in 1998. Originally a colony called SCAM, the Zeta Omicron chapter has the tradition of helping with Special Olympics bowling in Zanesville. Their colors are crimson and pearl, with the ladybug as their mascot. The founding members are seen here on what used to be Stormont Street. (Courtesy of Alpha Sigma Alpha.)

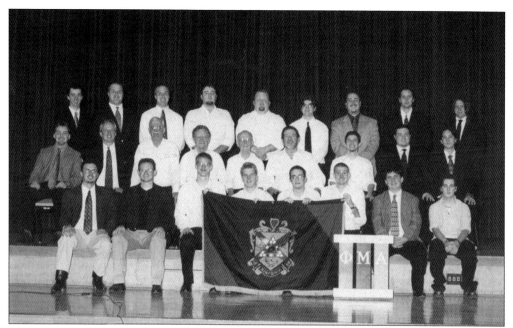

The Beta Lambda chapter of Phi Mu Alpha first appeared in 1931 originally as the Super Tonic Club. This group existed on campus as a music honorary until 1956, when it ceased to function. In 1994, the chapter was reactivated as an honorary fraternity. Here is a picture of them after their fall concert in 2002. The social aspect of the Sinfonia organization became increasingly important for the chapter, and by 2005, it was functioning as a social club. (Courtesy of Russ Brown.)

Lambda Chi Omega came to campus in 2003. This group was founded as a faith-based sorority and hosts weekly bible studies in its house, as well as interclub functions such as "girls night." Its mascot is the sheep, with the colors purple and blue. This picture from the 2004 *Muscoljuan* is a group picture of them after their varsity review practice for their performance of *STOMP*.

Community service activities—most of them student-initiated—have increased significantly in recent years. Here members of the class of 2005 and their mentors are pictured painting a map of the United States for the New Concord Elementary School. Another new tradition is the American Cancer Society's Relay for Life. Held every parents' weekend, this is a great way for students and their parents to help raise money for the battle against cancer.

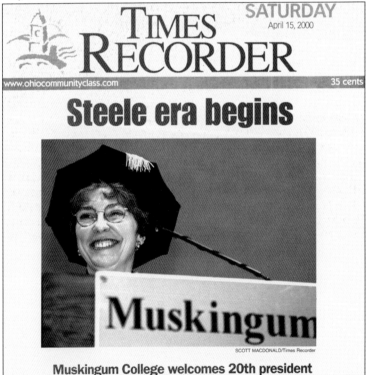

On April 14, 2000, Dr. Anne Steele was inaugurated as the 20th president of Muskingum College. In her inaugural address, Dr. Steele coined the phrase "the Long Magenta line," a vivid description of the close ties Muskingum alumni retain with their alma mater. (Courtesy of the Zaneville Times Recorder.)

The members of the Muskingum College Board of Trustees lead the Steele inauguration ceremony. Pictured from left to right are (first row) Harold W. Kaser; Gordon E. Spillman; Emily Pilcher; C. William Fischer; Miriam G. Schwartz; Anne C. Steele; Anna Castor Glenn; Jaime Bermudez Sr.; Robert W. Patin; Kim Gage Rothermel, M.D.; Craig A. Anderson, M.D.; and R. William Geyer; (second row) Rick Nutt; Branko Stupar; Allen E. Loomis; William A. Cooper; Larry A. Caldwell; Gordon F. Litt; J. Stark Thompson; Harold W. Burlingame; Carl F. Kalnow; J. Merle Rife Jr.; Hon. John Glenn Jr.; William T. Dentzer Jr.; Gerald L. Draper; Ruth Ann Duff; Robert E. Fellers; Ruth Champlin Hefflin; Dennis D. Grant; Anne Marshall Saunier; Jane Power Mykrantz; Myron E. Moorehead II, M.D.; Dennis D. Berkey; and Philip Caldwell.

The first distinguished professorships in Muskingum College's history were installed during the Steele era. Pictured above are the persons these chairs honor. From left to right are (top row) Homer A. Anderson (Anderson Distinguished Professorship in the Natural Sciences), Arthur and Eloise Barnes Cole (Cole Distinguished Professorship in American History), and William L. Fisk (Fisk Distinguished Professorship in History); (middle row) Harry and Mary Evelyn Cather Laurent (Laurent Endowed Chair of Psychology) and Dave Longaberger (Longaberger Chair in Teaching and Learning); (bottom row) Bill and Martha Lovejoy (Lovejoy Endowed Chair in Biology) and John and Ruth Dorsey Neptune (Neptune Distinguished Professorship in Fine Arts).

In 2002, the college broke ground on a cutting-edge communication arts center. A rainy forecast did not dampen the enthusiasm, but the ceremony was moved inside. Pictured here from left to right are J. Stark Thompson, William Dentzer, Hal Burlingame, Dr. Anne Steele, Wilson Caldwell, Philip Caldwell, William Fisher, and Al Loomis.

The building was named in honor of Philip and Betsy Caldwell in recognition of their leadership and generosity. Caldwell Hall houses the theater, speech and communications, and digital media design programs, as well as the campus television and radio stations.

The Walter K. Chess Student Center opened its doors in the fall of 2008. Pictured in the inset are longtime Muskingum College supporters Walter (class of 1943) and Marcia Chess. The spacious student center features an events hall, game room, fitness center, aerobics studio, snack bar, seminar classroom, and meeting rooms.

One of the most dramatic and campus-altering feature of the Chess center is the bridge that connects the east and west residential hills. New Muskies will no longer make the long hike up and down these hills when visiting friends on the other hill. Here the senior class of 2008 crosses the new bridge just before graduation.

Also opening in the fall of 2008 was the John and Ruth Dorsey Neptune Art Center. The Neptune center provides much-needed space for 3-D art and is an essential part of a revitalized east campus. As students at Muskingum, John (class of 1942) majored in chemistry and Ruth Dorsey (class of 1940) majored in art. Both returned briefly to Muskingum to serve on the faculty in the chemistry and art departments before moving on to other pursuits.

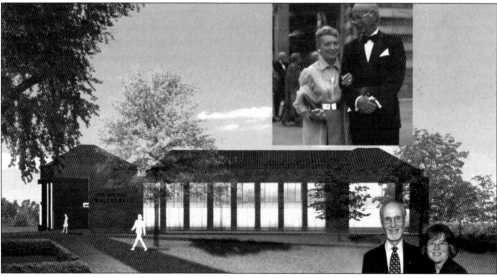

In April 2008, Muskingum College broke ground for a new music building named for Fran and Otto Walter (top inset), whose foundation made it possible. Otto arrived in the United States after being driven from his native Bavaria by Nazi persecution and became a renowned international jurist and a powerful voice for German-American reconciliation in the years after World War II. The current president and vice president of the Walter Foundation, Frank (class of 1951) and Martha Helman, are also pictured (bottom).

Across America, People are Discovering Something Wonderful. *Their Heritage.*

Arcadia Publishing is the leading local history publisher in the United States. With more than 3,000 titles in print and hundreds of new titles released every year, Arcadia has extensive specialized experience chronicling the history of communities and celebrating America's hidden stories, bringing to life the people, places, and events from the past. To discover the history of other communities across the nation, please visit:

www.arcadiapublishing.com

Customized search tools allow you to find regional history books about the town where you grew up, the cities where your friends and family live, the town where your parents met, or even that retirement spot you've been dreaming about.